WITCHCRAFT THROUGH THE AGES
THE STORY OF HÄXAN, THE WORLD'S STRANGEST FILM, AND THE MAN WHO MADE IT

First published by FAB Press, October 2006
FAB Press, 7 Farleigh, Ramsden Road, Godalming, GU7 1QE, England, U.K.
www.fabpress.com

Edited and designed by Harvey Fenton,
with thanks to Francis Brewster for production assistance.

A CIP catalogue record for this book is available from the British Library.
ISBN 1-903254-42-6

Acknowledgements
The author would like to thank Maren Pust, former editor of the Danish film journal,
Kosmorama, for various forms of assistance, and would also like to thank the late Anton
LaVey for initially stirring his curiosity about *Häxan*. LaVey's insights, imparted during late
night visits to his black house in San Francisco in 1991 and 1992, were invaluable.

The publisher would like to thank Gavin Baddeley, Lucas Balbo and Nigel Wingrove
for supplying some of the rare illustrations reproduced in this publication. Illustrations
are copyright © their respective owners, and are reproduced here in the spirit of publicity.

Front cover illustration
A demon surveys the attributes of a young lovely who has given herself to the cause.
Frontispiece illustration
Witches confessed that at night they transformed into animals
and soiled the holy altars of churches.
Title page illustration
Pen and ink sketch of Benjamin Christensen from 1945.

Witchcraft through the Ages

The Story of Häxan, the World's Strangest Film, and the Man Who Made It

Jack Stevenson

Contents

Introduction

Benjamin Christensen's macabre masterpiece from 1922, *Häxan* (*The Witch*), can justifiably be called many things. It can be considered the first cult movie, a genuine 'film maudit' (literally a 'cursed film'), the first true feature-length documentary (along with *Nanook of the North*, which was made the same year), and so forth.

Many of these same things can or could have been said about Tod Browning's much better known (and very different) film, *Freaks*, made a decade later. Indeed, these two taboo-shattering works occupy an exclusive niche in the annals of horror cinema and share uncanny similarities. Both were greeted by angry protests upon release, and were widely censored and fiercely condemned. Both were originally disasters for the studios that backed them, monster movies that weren't monster movies. To 'decent folks' these were the two most morbid, perverse films ever made, while to advocates they shone with a very human vision. To the men who made them they were the consuming obsessions in their lives, the films they were put on earth to make, labours of love that according to the lore destroyed their careers, and turned two gregarious, extroverted young men into embittered hermits and haunted them to their graves.

'The lore' of course always tends to the melodramatic, but these two supremely gifted but troubled directors – one American, one Danish – did share a common fate... Both were tall, dashing, talented and 'difficult,' and both held a fascination for the dark side of life. Both were employed at

MGM studios in depression-era Hollywood where they each made films with Lon Chaney and solidified reputations as masters of horror... but they never met.

Browning didn't completely follow the script. He made more films after *Freaks*, some well received, before retreating from public life to live in solitude.

Ditto Christensen, although much less is known about him. Only one slim book has previously been written about the man, thus far still available only in Danish. What additional information that does exist on him tends to be filtered through the narrow prism of academic interpretation and the man himself rarely makes an appearance.

The goal of this book is to place *Häxan* in the context of Christensen's wider career, since the film did certainly overshadow most of his professional life, and to place it within the context of the times. This has required extensive research into the Danish source material, and it was necessary to translate much of the initial reaction in order to present a picture of things at the 'moment of impact.' Many of the issues that embroiled his film upon release are still, amazingly, being hotly debated today.

Who was this man who could make such a film, and what drove him? We still don't know for sure. Christensen, the consummate 'man of mystery,' wouldn't have had it any other way.

Mystery man, Benjamin Christensen.

The Early Years

Ironically, the man who was to create the most perverse and profane work of early cinema was born in the shadow of a crucifix – a massive crucifix-shaped cathedral that dominated the ancient city of Viborg, which during Medieval times was Christendom's stronghold in the Western Danish provinces of Jutland.

He came into the world on 28 September, 1879, dubbed Benjamin Christensen, the youngest of twelve children. And although he was to achieve much during his life, this was no rags to riches story, his father ranking as one of the town's most prosperous merchants and one of its most well-to-do and influential citizens. As befitted his family's status, young Benjamin attended the Cathedral School, the town's finest, where he was versed in classical languages. But the boy had an independent streak and after graduating from school he travelled to Copenhagen to study medicine.

A funny thing happened on the way to a medical career – he started singing. One morning while shaving over his sink, the renowned opera singer, Nyrop, overheard him and stuck his head round the door – 'Who on earth is *that*?!' He convinced young Christensen to give the opera a go and the lad entered into some months of preparatory voice training. In 1901 he and forty other hopefuls applied for admission to the prestigious Royal Theatre's opera school and he was the only one to be accepted.[1]

He had his debut on 2 May, 1902, playing the naïve young peasant, Mazetto, in Mozart's *Don Juan*, but disaster struck that very night when a lump formed in his throat during the

performance and his voice grew weaker as the evening wore on. He was told by doctors that his throat was okay but that he had an untreatable nervous condition. He had the support of major figures in the Danish opera world; he had been tipped to take over the repertoire of the highly respected Helge Nissen, and was to have sung Mephisto's part in Gounod's Faust,[2] a 'dream role' as he himself characterized it. And now an illusive illness that was maddeningly untreatable had ruined it all. In one stroke the great future that had been predicted for him was dashed.

above:
Christensen as Mazetto in 'Don Juan' in 1902.

left:
Young Christensen (right) as an actor at Århus Theatre.

Forced to quit the opera, he entered acting school. After graduating he was engaged to perform for three seasons at a new theatre in Århus. There he played a wide range of characters and roles, performing with some of the best Danish thespians of the day including Betty Nansen and Bodil Ipsen. It was also here that he did his first directing, but reportedly relations between Christensen and at least some of his colleagues were strained, with one scribe later maintaining that he got such good reviews that his fellow actors felt cheated of recognition, and accused him of unduly influencing the writers.[3]

Christensen was a loner who always followed his own path, and now that path led back to Copenhagen. There he managed to get parts in several plays but once again his voice began to betray him. While playing the role of the genie in *Aladdin*, the audience was compelled to yell 'louder, louder!' throughout the evening. In 1907 he was forced to retired from the stage forever.

His great baritone singing voice would return on occasion over the years, but never when he needed it and never when he was confronted by a live audience. According to his own account, years later he even ran into the great Enrico Caruso, who overheard him singing in his bathtub in his hotel room in New York and asked Christensen to join him on stage. The Dane tried to explain that his voice would falter the second the curtain went up. Caruso was incredulous that anybody could turn down such an offer and walked away shaking his head in disbelief.[4]

Some difficult years followed his departure from the acting profession. He had married the actress Ellen Arctander in 1904, and now they had two little boys so he was forced to hustle to support his family. He worked as a proof-reader for a

daily paper and exported potatoes to Germany before finding a better paid job selling high quality champagne for the French company, Lanson Père et Fils. As their agent in Copenhagen he was obliged to frequent all the high-class drinking establishments, which he did without complaint. One writer would later describe him as "living a mysterious double life" at this point.[5] In fact he became something of a post-Victorian party animal, gadding about like royalty on the company's generous expense account and freely imbibing of the liquid goods himself.[6]

One day it all became too much for him. Ever fond of dramatic gestures, he ceremoniously drew up a document that stated that if he didn't abstain from alcohol as of that date then he was an irresponsible father to his young sons. Thereafter he pulled one of the little boys up onto his knee and, guiding his little hand, had him sign the document, which he then signed himself.[7] And according to him, he honoured it. That might have been a matter of degree, however, since he remained an agent of Lanson Père et Fils after his film career began – loathe to give up a significant income – so bottles of bubbly were always on hand at his social gatherings and offered to actors on occasion as pick-me-ups when their energy flagged. And in many of his films there was the obligatory Champagne-drinking scene in what must have been one of the first examples of 'product placement.'

According to the lore handed down over the years, Christensen's decision to go into film was prompted by a disturbing scene he witnessed one day when he left his house; there on the far side of the street was the famous actress, Asta Nielsen, being led away by police officers. Nielsen had studied privately with one of his acting teachers and they were friends, so he was understandably distraught and rushed over to help – only to discover that this was a film shoot (actually the

closing scene of her 1910 film, *The Abyss*.) (The story has since been discounted by some writers as 'too good to be true,' but in fact he did live directly across from where that scene was filmed.) He claims he was bitten by the 'film-bug' then and there, his eyes opened to the dramatic potential of a medium he had not previously held in particularly high esteem. That very night he launched into his first script.

When in 1912 he finally began to work in film as an actor he was no star-struck youngster. He was by now 33 years old with plenty of experience in both theatre and opera, and he had lots of friends and connections in the fledgling film industry. And he had life experience – he had been a salesman, a businessman, a family man, and he had known lean years. He was an artist but also a pragmatist. Film was perfect: with no live audience – and no sound – he wouldn't have to worry about his voice failing him.

There is some uncertainty as to how many films he acted in between 1912 and 1915. Some sources mention as many as five,[8] (see the filmography for a full accounting of Christensen's work during this period). In any case his first film was *The Belt of Fate*. It was made for Carl Rosenbaum who had had success with a picture called *The Four Devils* in 1912 and who now had his own studio thanks to a group of German investors who hoped he would continue his money spinning ways. He had made Christensen's acquaintance beforehand and hired him to play the lead, that of a blind musician with an unfaithful wife. In the film he presents her with a cursed article of apparel, a belt that will cause any adulterer who dons it to die. After giving her the belt, he commits suicide. She later puts the belt on... and dies, the curse having come true.

The film is now lost, but is believed to have been directed by Svend Rindom, who had been an acting colleague of

Christensen's first film role as the blind musician (right) *in **The Belt of Fate**.*

Christensen's in his days at Århus Theatre and had helped Rosenbaum write the script to *The Four Devils*. Christensen was reportedly dissatisfied with the quality of the production and in 1913 signed with another company, Dania Biofilm. For them he acted in *Little Claus and Big Claus*, playing a doctor.

That same year he saw Albert Capellani's movie, *Les misérables*, which was screened for the benefit of Copenhagen's actors in the magnificent Palads (Palace) Theatre. The screening made a deep impression on the whole audience, not least Christensen who remembered it as a decisive turning point for him. Everything that film was capable of was here suddenly demonstrated. The experience must have increased his impatience with the humble productions he himself was at that point involved in.

A pen and ink drawing of the Palads Theatre, circa 1912.

In March 1913 a group of Danish investors from Århus bought out the Germans and took over Rosenbaum's company (The Dansk Biograf Kompagni). They quickly grew dissatisfied with Rosenbaum's performance; he had spent a lot of money and only made the one movie, *The Belt of Fate*. In the meantime Christensen continued to try to sell the script he'd written the night he saw Asta Nielsen's performance out in the street. After reportedly offering it to August Blom for 20,000 kroner cash, he presented it to the Dansk Biograf Kompagni. Both Rosenbaum and the board were impressed by it, and he assumed operational control of the studio to make it.

That script would become *The Mysterious X*.

'The Mysterious X'

Christensen directed *The Mysterious X* in Taffelbays Allé, in Hellerup, a well-to-do town just north of Copenhagen. (Hellerup had plenty of luxurious villas that made ideal shooting locations and many of the early Danish silent movies were filmed there.) He was a kind of one man band on this film, writing, directing and also playing the lead character, the gallant Navy Lieutenant, van Hauen, who is entrusted with a set of secret orders. Enter one Count Spinelli, a treacherous cad who attempts to seduce his beautiful wife (she beats off his advances) and steal the orders. Spinelli finds them while prowling the house, fleeing when van Hauen arrives and spots him. Our hero is uncertain what his wife's involvement with the villain is, and when put on trial for treason – the seal on the orders having been broken – he refuses to divulge what he knows for fear of compromising her honour, and is sentenced to death. His wife, in turn, thus far puzzled by his behaviour, has a dream that makes everything clear to her, prompting her to alert the proper authorities. A messenger's last minute dash on horseback manages to save an innocent man's life.

It was hailed as the best Danish film of 1913, no small accomplishment considering the global success that Danish films were then enjoying on the world market.[9] But it was more than that according to modern day historians, among them Denmark's leading Christensen scholar John Ernst. He states that *The Mysterious X* and August Blom's *Atlantis* of the same year were the two most modern works of world cinema prior to Griffith's *The Birth of a Nation* and *Intolerance*.

Heady praise indeed, but deserved. At a time when so many films were based on novels, Christensen had filmed an original story and dispensed with the literary clichés that informed so much of the competition. He had shown an ability to transform psychology into physical action, and his interplay between light and shadow was innovative and dynamic. He also departed from conventional film style by letting inanimate objects play parts, so to speak. In this film a trap door closes and becomes tightly wedged, imprisoning the villain who struggles desperately to open it. In other films a door is opened by the wind and a lamp is borne through the darkness by a man who cannot initially be seen. Christensen had been deeply moved in *The Four Devils* by the simple sight of an empty trapeze swinging back and forth in the circus tent, after the acrobat who was to grab it missed and had fallen to the ground. To him it was the most affecting part of the whole film.

The Mysterious X evidenced an attention to detail that would become Christensen's trademark. Every little nuance had been thought out to an unprecedented degree, with some of the scenes having been re-shot eight or nine times. This also made for a film that took an unusually long time to shoot (three months instead of the typical two weeks) and was expensive – more Christensen trademarks.

This was due, to some extent, to his desire to experiment. In later years he would claim that *The Mysterious X* contained the first scene of anyone turning a light on in a room, a challenging 'special effect' in those days when movies were shot outdoors or in glass-walled studios where the sun was the main source of light. He had twelve men lay on the roof of the glass-panelled studio which they had covered with a tarp. Actress Karen Sandberg came into the dark room and put her hand on the light switch. The camera stopped while

she froze in that position and the tarp was pulled off by the workers. The camera was started again and presto – a light had been turned on!

Perhaps this 'trick' had been done before, but so what? He had done it well (reportedly impressing American critics) and perhaps more importantly it was a good story and he was, above all else, a good story-teller. In Denmark, where the picture was promoted as a "sensational Danish drama," the critics were likewise impressed. One writer praised him for packing in enough "beautiful landscapes, burning windmills, ravenous rats, condemned men, dreadnoughts and subterranean dungeons" to fill five or six normal films.[10]

The Mysterious X was released first in America in 100 prints, its premiere held during March 1914 in a large New York theater. It went on to earn accolades in the American trade press, which was not usually receptive to 'stagy' European films. It was championed by advocates of the young medium such as one Stephen Bush, who wrote in that month's edition of *The Moving Picture World*: "This feature is nothing less than a revelation in dramatic motion pictures. It sets a new standard of quality. It emphasizes as no other film production the absolute superiority of the screen over the stage and opens up a vista of coming triumphs... An extraordinary boldness of invention joined with a mastery of detail that approaches genius helps to make this feature rise above all which has been filmed before."[11]

The American buyer had also acted with 'extraordinary boldness' by shoving 400,000 dollars of the film's 600,000 U.S. gross straight into his own pocket, and leaving none for Christensen, according to an article in the Danish press.[12] For a film made for just 30,000 kroner this was in any case amazing box office.

Christensen himself travelled to New York and throughout Europe to sell the film. These 'sales trips' were adventures in and of themselves. "I sat next to people in black leather boots in Moscow and with cigar-puffing theater owners in New York." In Europe the film itself was suspect; as the Great War loomed, spy films had been outlawed in Germany and the Austro-Hungarian territories, and were considered unnecessary incitements in other countries.

While in Berlin in 1914 a fateful event occurred – he stumbled upon a copy of a book called *Malleus Maleficarum der Hexenhammer* (*The Witch Hammer*), a guide for witch-hunters written in 1487 by the two infamous inquisitors, James Sprenger and Heinrich Kramer, who were also Dominican monks. Called 'one of the most blood-soaked works in human history,' it was widely read for much of the 250 years the Inquisition lasted, its popularity exceeded only by the Bible. It is renowned today as the most infamous of the witch-hunting manuals which over the course of roughly three centuries helped to send as many as nine million (eight million is often cited) victims, primarily women, to their deaths, often on bonfires. (This figure is contested today by historians who claim it was a gross exaggeration and that the actual toll was between forty and fifty thousand.) Christensen himself found it to be "one of the most perfidious documents ever published,"[13] but he was also completely fascinated by it. On that same trip he passed through Paris where he found a copy of *La sorcière* by Jules Michelet, a study of witchcraft and the phenomenon of the persecutions. "After reading these two books," he would later note, "I was seized by the intensely dramatic power of the material[14] ... it was clear to me that I had finally found a subject."[15]

He immersed himself in this dark history and began to collect all the books about the subject that he could find. At about the same time he was made aware of the lectures of the world famous neurologist, Professor Charcot. Charcot claimed that the symptoms (of hysteria) he found in his patients were the same that caused 'witches' to act as they did when they were 'possessed,' and, more controversially, that the female Saints also suffered from this same form of hysteria.

All this research laid the groundwork for the film that would come to dominate his career and his life, *The Witch*,[16] but that was still years down the road and at that moment humankind was being sucked into another kind of mass hysteria of even more destructive proportions – The First World War.

The War had an effect on every aspect of life in Europe, including the financing and exportation of motion pictures, and Christensen was compelled to abandon his next film project, *The Man Without a Face* (*Manden uden ansigt*), despite the fact that Nicolai Neiiendam had been chosen for the lead and shooting had already begun.

'Blind Justice'

By August 1915 Christensen had managed to acquire a controlling interest in the Dansk Biograf Kompagni. The members of the board stayed on but it became 'Benjamin Christensen Film' and was run from his home. His financial backers were, according to one report, a bunch of rich people from Århus who were involved with it almost 'for sport.'[17]

Now he was certain to again have total creative freedom on his next film, *Blind Justice*. Shooting on that picture started in the fall in the same studio in Taffelbays Allé where he'd shot *The Mysterious X*. This time around the very capable Johan Ankerstjerne would be manning the camera.

Christensen would again play the lead. While his previous performance had been marked by bouts of frenetic overacting, here he would comport himself with more subtlety as 'Strong Henry,'[18] a slow-witted circus strongman who has been wrongfully imprisoned. One day he escapes from jail, gathers up his infant son and makes a dash for freedom, but a sudden storm forces him to seek shelter in a nearby mansion. There he encounters Eva, who is at first terrified but then agrees to help him for the sake of the child. Her father senses something is wrong and forces her to tell all. The cops are called and they drag Strong Henry back off to prison as he vows revenge. The child is placed in an orphanage. Eva eventually marries and convinces her husband that they should adopt the lad.

Fourteen years later Henry is released from prison, a broken man. He enters a toy shop to purchase a gift for his son but can't even remember how old the boy would be. When he arrives at the orphanage he is shocked to learn that his son

Christensen as a young 'Strong Henry' in **Blind Justice**.

was put up for adoption long ago and that his whereabouts are unknown. He stumbles dejectedly about town until he bumps into an old crony from prison who invites him to join his gang of small-time crooks.

During the course of one of their capers they manage to pilfer the keys to a townhouse. While ransacking the premises, which unbeknownst to Strong Henry is owed by Eva and her husband, they find the address of their villa in the suburbs. She had always lived in dread that one day he would come to extract his revenge, and now her fears come true.

Eva's husband is lured to the gang's hideout where he is overpowered and tied up in a chair. Yet in his haste he had forgotten his keys when he departed the villa and now the son shows up with them in hand. Henry, oblivious to the fact that the lad is really his own son, locks him into a cupboard and sets off for the villa. Meanwhile the captives manage to free themselves and alert the police. Just as Henry takes aim at Eva through a series of keyholes the cops arrive and open fire. Henry is mortally wounded, but on his deathbed is absolved of his original crime when the real murderer makes a timely confession. Now cleared of all charges and reunited with his son, he dies in peace.

As John Ernst writes, "Audiences at the time were just as enthusiastic about *Blind Justice* as they had been about *The Mysterious X*. That we must today rate *Blind Justice* as a lesser work owes first and foremost to its melodramatic, sentimental

Witchcraft Through the Ages

story and its pseudo-realistic nature, which quite understandably was construed as realism. This pseudo-realism also characterizes *The Mysterious X* but is less of a drawback here since that *was* an unrealistic spy story to start with, one that took place in 'no man's land'... *The Mysterious X* is a far more pioneering achievement."[19]

Christensen as the aged 'Strong Henry' in ***Blind Justice***.

While another great master of early Danish cinema, Carl Dreyer, believed that films should be based on literature and that the director should be true to that source material, Christensen believed that scripts should be the result of original ideas and that the finished work should bear the mark of the creator's personality. The two above-mentioned films very much did, not least because Christensen wrote, directed and played the leads in both. His own face even dominated the key promotional art of *The Mysterious X*, staring sternly ahead in three different guises while captions trumpeted: "written by Benjamin Christensen... Directed by Benjamin Christensen... In the lead role, Benjamin Christensen." A promo blurb went on to declare: "Benjamin Christensen's new film is absolutely the very best film and absolutely the very best premiere-quality picture ever staged in Denmark."

This was sweet vindication. Christensen had previously seen a brilliant career in the opera slip through his fingers because he could not control his greatest gift – his voice – even though there was, physically speaking, nothing wrong with him.

Now he had found a new medium of expression where he could control almost everything down to the smallest detail, and that's what he aimed to do. It was a world of his own making, a world he could create and control.

He carefully sculpted the physical as well as the emotional frames. In *Blind Justice*, for example, he had the set designer build a scale model of the villa which can be seen in the prologue. He stands over it with actress Karen Sandberg, discussing the plot and casting a dominating shadow over the proceedings. Scholarly writing on the film tends to interpret this as a testament to his great care and attention to detail, and he did indeed possess these qualities in spades; in his zeal he reportedly put his actors through the tortures of the damned. For example, he compelled Karen Sandberg "to spend many hours staring at that dollhouse (of the villa) to get a feeling for the setting of the film, to learn where certain rooms were situated in relation to others."[20] Hermann Spiro, who played the evil Count Spinelli in *The Mysterious X* underwent a somewhat more challenging ordeal as Christensen contemplated the best way to depict a swarm of rats attacking and devouring him in a sewer tunnel. Notes a writer at the time: "At first he smeared the actor's face with honey and set a whole basket of the vermin after him, and when that didn't work he made a dummy with Spiro's face carved in cheese and the rats went amok on it."[21] On *Blind Justice* he did an unheard of ten takes of every scene to capture exactly the effect he wanted, drawing out filming and post-production to a whopping eight months and making it the most expensive Danish film at that time after *Atlantis*.

Christensen was indeed a painstaking craftsman, but there was certainly more to it than that. To consider him primarily as an artist rather than a person – a person who had

suffered a great trauma when his voice betrayed him, and who perhaps not unexpectedly now became something of a 'control freak,' to use the modern expression – is to miss the real story of Benjamin Christensen. The man himself, as noted, was an extraordinary storyteller and would have never forgiven writers for ignoring that. God knows he left enough clues strewn in his wake. In any case, the success of *Blind Justice* was another career boost. He was now a maker of films that had social relevance and were also exciting and original. And sensational. He always thought that films should be 'sensational.'

In New York film censorship authorities invited him to show the picture for an invited audience of VIPs from the cultural world. Among them was the warden of Sing Sing prison, Thomas Mott Osborne, a humanitarian dedicated to improving the lives of convicts. He had even spent several weeks inside the institution disguised as a common prisoner so as to get to know the true nature of the place. He now invited Christensen to show *Blind Justice* for the inmates in a huge hall with a capacity of about 2,000. The screening made quite an impression on Christensen, not least because during the show there was a stabbing. The guilty party was immediately hustled out by two other prisoners acting in accord with the 'honour system' that Osborne had instituted, whereupon inmates policed themselves – all of this according to the account Christensen later gave in 1945 when he published a compendium of short stories entitled *Hollywood Destinies*.[22]

As Ernst relates, "The prisoners were as keenly impressed with the film as Christensen was with their intelligence and sensitivity, and with the (in any case at that time) advanced conditions at the place." He never forgot his visit to Sing Sing and would later claim that it inspired him to embark upon a study of the nature of evil. And for their part the prisoners

never forgot *Blind Justice.* During his Hollywood period in the late Twenties he was still being approached by ex-cons who had seen the film at that screening and wanted to express their gratitude.

America imported relatively few films during the First World War, but *The Mysterious X* had been popular and Christensen managed to sell the new picture to Vitagraph, which released it in forty prints. The premiere took place in New York's 3,500-scat Strand theater to the accompaniment of a fifty-piece orchestra. The crowd was silent during the show and that made Christensen nervous, but when the curtain came down there was hearty applause. It had been a rousing success. He was immediately approached by interested distributors, and that night also got to meet Mary Pickford.

At some point in the process he commented to Vitagraph executive, Albert Smith, that he intended to make a trilogy about superstition down through the ages, and that this work would constitute a radical break from the conventions of the medium. It would be entitled "The History of Superstition." The first part was to be called *Heksen (The Witch)*, to be followed by *Helgeninde (The Woman Saint)* and *Ånder (Spirits)*. "I don't think that's anything American audiences would cotton to," Smith dryly remarked.[23]

While Vitagraph wasn't at all interested in his superstition trilogy, they did offer him another job – that of supervising all their productions. It was a tempting offer that was hard to turn down, but in the end he did. His head was full of his next film, *The Witch*, and there wasn't room for anything else.

And so he came back to Denmark to make it.

The Making of 'The Witch'

Christensen began to research *The Witch* in earnest. Subsequent exaggerated utterances in the press inferred that he had acquired a whole library of rare books on the subject, when in fact all his books could fit into a single streamer trunk (later stolen in America), but it was nevertheless an impressive collection.

A year-and-a-half later he ran out of money and was forced to sell much of his beloved antique furniture in order to continue. "I remember," he later recalled, "the sight of my two sons standing in the doorway with tears in their eyes as the furniture was being carried away."[24] One might also speculate as to the effect this morbid obsession had on his marriage, inasmuch as he and his wife, Ellen Arctander, were divorced the following year, in 1920. It took Christensen two-and-a-half years just to undertake the research on this film.

He had doubted that any producer in Denmark would be "crazy enough" to gamble his money on a film that was this far-out and unconventional, and he was right – but a producer in Sweden *was* willing to take up the challenge, a man named Charles Magnusson, and in February 1919 Christensen inked a contract with Svensk Filmindustri. Since it was now being made with Swedish money it would go down in history as a Swedish film, with the Swedish spelling of the title, *Häxan*, the official one, and it would have its world premiere in Stockholm, but in all other respects it was thoroughly Danish.

Magnusson was a visionary producer who was largely responsible for the excellence of Swedish silent cinema, having given talented directors like Victor Sjöström and Mauritz Stiller

creative freedom, and now he afforded Christensen that same luxury. For that 'Benne,' as friends called him, would remain ever grateful. But there was a vast amount of work to be done before even a single frame of film could be exposed.

First they needed a studio to shoot the movie in since there were none available in Sweden. Benne persuaded Magnusson to buy him back his old studio in Taffelbays Allé. He had sold it in 1917 to another company and it was again up for sale, albeit in terrible condition. There were no working toilets or bathrooms, and what technical apparatus remained was antiquated. Svensk Filmindustri had to purchase new cameras, lighting equipment, etc. The actual cost of shooting was reckoned at between 300,000 and 400,000 kroner, but all this added expense ballooned the budget up to somewhere between 1.5 to 2 million kroner, a whopping sum that earned it the dubious distinction of being the most expensive silent movie ever made in Scandinavia.

Filming began in late winter of 1921 and lasted throughout the hot summer months and into October, most of it done in Taffelbays Allé, but with a few scenes shot at two other nearby studios.

Christensen had cameraman Johan Ankerstjerne back for another turn. A barrel maker's son from Randers whose first brush with the working world was as a watch maker's apprentice, Ankerstjerne's life was changed the day he was given a movie camera to fool around with. He aimed it at what drama and pageantry there was to be found in the small Jutland city, various parades and municipal events and whatnot. He went on to become a skilled cinematographer and was already exceedingly accomplished in the trade when in 1911, at 25 years of age, he was brought to Copenhagen by Ole Olsen's Nordisk Film Company. These were exciting times for

the Danish film industry as actors like Valdemar Psilander and Asta Nielsen were achieving global fame and production was booming. That year he shot no less than 27 films for Nordisk that went out onto the world market, and he stayed with the company until 1915, later serving another stint with them from 1924 to 1932. After that he founded a film laboratory and print-making plant that still exists and is one of the biggest in Denmark.

Not all of Ankerstjerne's work on *The Witch* confined him to the studio. At one point he travelled to the town of Silkeborg with his equipment to shoot background footage devoid of telephone wires, modern rooftops and other tell-tale traces of the 20th Century. This area in Jutland, which is also one of Denmark's most rugged, was ideally suited for this task. He also shot footage at nearby Himmelbjerget, Denmark's highest mountain – modest as it is – for what would prove to be the most spectacular scene in the film, the flight of the witches to Bloksbjerg ('Brocken' in English subtitles), the medieval town in northern Germany where according to legend all witches gather on the summer solstice to indulge in profanities with the Devil.[25] Christensen also sent cameramen to remote parts of Norway and Sweden to shoot roll after roll of clouds and mountaintops. They shot a vast amount of footage, much of it in fact unusable for one reason or another.

One can infer from comments published over the decades that Christensen, being an obsessive, a perfectionist and perhaps even a genius, was not always easy to get along with, but he did have an excellent relationship with his cameraman and was thrilled with his work. Ankerstjerne's photography and effects surpassed what the Hollywood studios were capable of, even with all the state-of-the-art equipment they had at their disposal.

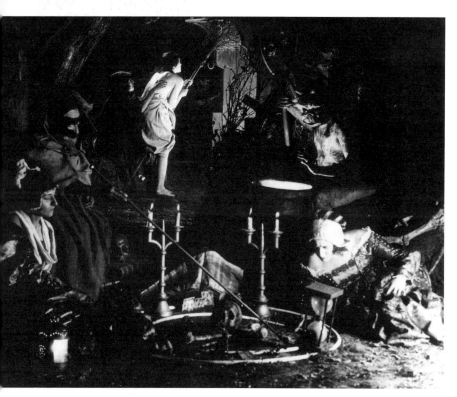

above: *Various Satanic posturings take place in the Devil's lair in Bloksbjerg.*
opposite: *The flight of the witches to Bloksbjerg.*

Richard Louw, the props and sets man, was equally
indispensable. The medieval torture instruments he created
were works of art. And he even found time to construct a scale-
model version of a Middle Ages town complete with 250
miniature dwellings. The village was mounted on a large
carousel twenty metres in diameter and filmed from the edges
as twenty men turned it.

The aforementioned flight to Bloksbjerg, which prompted
spontaneous applause at many shows and still manages to

amaze, was an equally painstaking and time consuming scene to construct. The scores of women[26] who acted as airborne witches were filmed separately on elevated and unseen seats with broomsticks placed between their legs while wind was blown at them by an airplane engine adapted for the purpose. This in combination with the camera tracking past them provided the illusion of motion, of flight. (It was originally intended that trees and landscapes shot from a fast moving train could add to the sense of rapid movement but this footage proved unusable.) The actresses were filmed from various distances and angles and with different camera movements. Then, via the multiple-exposure process, all the flying witches were assembled onto five spools of film. (Today this is a laboratory process but at that time it involved the painstaking work of cranking the film back and running it twice or more through the camera.) All the images were subsequently combined to create the scene. This consisted of two spools of clouds, one of the miniature village 'in motion,' and one roll with a woman

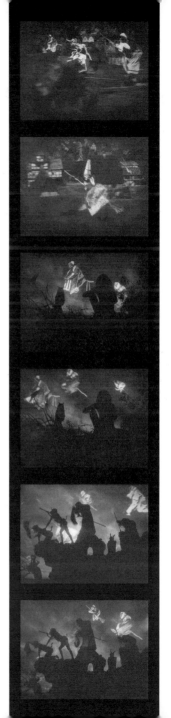

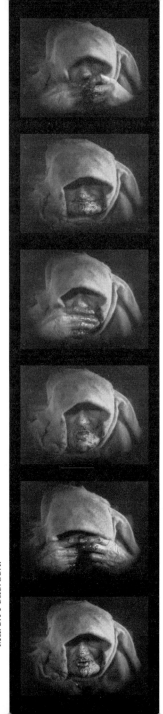

Maren Pedersen.

sitting on a knoll and demons poised on the edge of a cliff (all of whom observe the arrival of the witches) in the foreground, silhouetted against landscape features. Nine strips of film were then run not less than eight times together through an experimental optical printer Ankerstjerne had developed. The techniques he employed on this film were state-of-the-art and he also managed to create an animated stop-motion monster that can be seen at one point in another scene.

The cast was composed in the main of professional actors, many from the stage. Some of Denmark's most revered movie stars are glimpsed in *The Witch* for the first time. Christensen himself played the Devil with obvious relish (and no small amount of theatrical over-acting in period style).

But the lady who stole the show was an amateur, a 78-year-old woman by the name of Maren Pedersen. She played Maria, the weaver, an accused witch. Christensen had 'discovered' her one evening as he strolled out of the main gate of the city's famed Tivoli amusement park. The wrinkled old

woman was off to the side, sitting there selling flowers. She reached towards him with a clutch of violets and he was instantly struck by her appearance. He bought a bunch for two crowns and struck up a conversation.

Pedersen had been educated in her youth as a nurse. In her day she had been rather well off, at one point operating her own small clinic, but later things went downhill for her and now she was dirt poor, living at a home for aged women and selling whatever she could during the days. She was unnerved when this strange man then and there offered her the leading role in his movie. As he began to describe it she became increasingly apprehensive. She was a religious woman and feared that participation in such a thing would somehow be a betrayal of her beliefs. Yet he was a charming and persuasive gentleman, and on top of it they could converse in the same dialect as she came from the same part of Jutland. She finally agreed.

As journalist Mogens Brandt would relate, the first time Pedersen arrived at the studio the receptionist mistakenly sent her directly in to see Christensen. He had donned his devil mask and applied make-up in preparation for the shooting of a scene. He was more or less naked and painted over the whole of his body in such a way that his skin appeared covered with pustules. He had large fan-shaped ears, horns protruding from his forehead and a long flickering tongue.

"Good lord! It's the Evil One!" she gasped in a near swoon.[27]

Christensen tried to calm her.

"How do you know what the devil looks like?" he asked.

She pulled out a dog-eared prayer book and showed him a picture.

"He looks like that!"

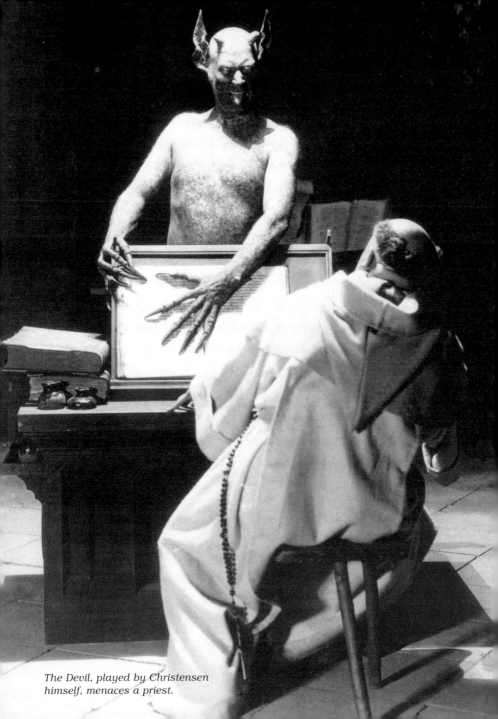

The Devil, played by Christensen himself, menaces a priest.

He tried to explain to her that that was only a picture and that the Devil didn't really exist, but she was having none of it. (This episode is related in the film itself.) She had *seen* the Devil with her own two eyes. Sometimes at night he came to her and sat down on the edge of her bed, and she would throw the sheets up over her head in a fright and pray to the Lord three times. After that, as a rule, he was usually gone when she peeked back out.

Years later Christensen would talk about how fabulously inspiring it had been to work with Maren Pedersen. She brought 'the real thing' with her into the studio; the kind of superstitious nature and belief in mysticism that had been commonplace during the Middle Ages. All that the film was about was still alive in her fragile body. She was a kind of muse for him, her withered face a portal back into the darkest reaches of antiquity, and he turned that face directly into the camera, exposing every wrinkle and crevice with an unflinching hand. Today this might seem unforgivably exploitative but at the time it was exclusively praised as a stroke of casting brilliance that imbued the film with a searing authenticity. And after all, he was paying her, right? By some accounts she enjoyed being a prima donna for a while and getting rides home after work in a big car.[28]

And yet some accounts of the filming can only be described as disturbing. Actor Ib Schønberg's first meeting with Pedersen was one such unsettling encounter, witnessing as he did how Christensen had fastened a leash onto the woman's leg which he pulled in order to get her to move toward or away from the camera. A stroke of casting genius or pure exploitation? As critic Tage Heft enthused, "During a torture scene the amateur performer Maren Pedersen really *was* about to faint. Christensen dried the sweat and tears off her face so that she

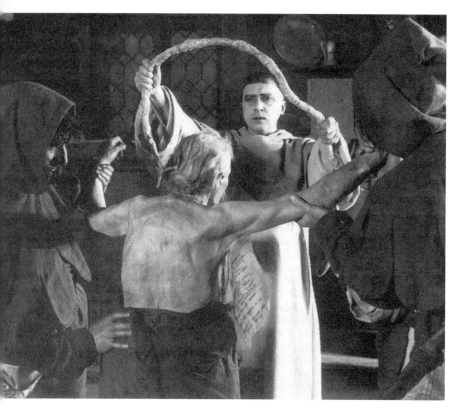

above: *The elderly Maren Pedersen being interrogated by priests.*

could continue. No 'honest' actor could play it so honestly."
Christensen himself hailed her as "excellent in the torture
scenes," although he would state that at no point whatsoever
did she have any idea what the whole thing was about.

Scholars have grappled with the question of what kind of
filmmaker and artist Benjamin Christensen was, yet all of this
more directly begs the question of what kind of *person* he was.
The shooting of the movie resembled more than anything else a
cult-like exercise in blind obedience, in getting other people to

play a part in one's own personal fantasies. Here more than in any other film he was attempting to create his own world.

This hardly detracts from his accomplishment. On the contrary; the best films are often personal fantasies brought to life by obsessed directors, and all films are about convincing other people (actors, audience, reviewers, etc.) to buy into your fantasies, but to what degree was the director himself caught up in his own creation? It's hard to say. The academic writing on the man that exists has failed to pose basic questions about who the real Benjamin Christensen was. Here was a man pulling an old lady around at the end of a rope, a man who cast himself as the Devil and who had beautiful witches kiss the buttocks of that hairy and frightful figure. And here was a man who persuaded one of the actresses to spit on a picture of the baby Jesus (a much more daring transgression in that day and age).

Christensen had always believed that actors must immerse themselves in their roles. What then might the Devil demand of young, attractive witches in exchange for his supernatural favours? And what might the witches be willing to do in exchange? There was little doubt about that; it was spelled out in the film – they would do anything for a pile of gold. What would they do in real life for the pile of gold of becoming famous movie stars? The making of the movie paralleled the story it was telling in uncanny ways. During the filming Christensen lived in quarters that were attached to the studio. What might that have made possible? To what degree did his personal fantasies figure into this professional fantasy he was creating?

The Witch, like many film productions, was an exercise in power and control, and there is no doubt that Christensen had not only total creative freedom but also total control. The film was being shot in the utmost secrecy – and at night! (when

producers from Svensk Filmindustri were least likely to drop by and nose around.) As he would later relate, "The film deals with hysteria and the dark side of human nature, and when the sun shines in the day it is impossible to call forth precisely those feelings in the actors."[29] He wanted to bring forth the actor's dark sides, but what about his own dark side?

He reportedly stressed them almost to the breaking point. As described in one report, "For key scenes he consciously strove to create a sense of real hysteria on the set. He let the actors do make-up and then wait. He began to shoot scenes and then stopped. He made sure they got a bit of food and then went through the whole process again from the beginning, up to that point having actually not yet shot a single metre of film... and then when the clock struck four in the morning and the actors were out of their minds for real, *then* he began to shoot the scenes he would use."[30]

Time doesn't heal all wounds, but twenty years on some of the surviving actors were able to look back at their experiences during the filming in a somewhat more rose-coloured light.[31]

Clara Pontoppidan (a nun): *It was all like an adventure out there in Taffelbays Allé. I went straight over there from the Dagmar theatre in the evening and often acted through the night until sunrise, and was then generously treated to a car ride home... I remember those days as a 'working high'... When once in a while late at night we grew dead tired, a good brand of Champagne appeared on the table and in that way the hard work and partying was part and parcel of the experience... And yet now, many years later, I must confess that it filled me with fear. After all, that was an intense performance I was asked to give. Only a man like Benne could have persuaded me to spit upon a picture of the baby Jesus...*

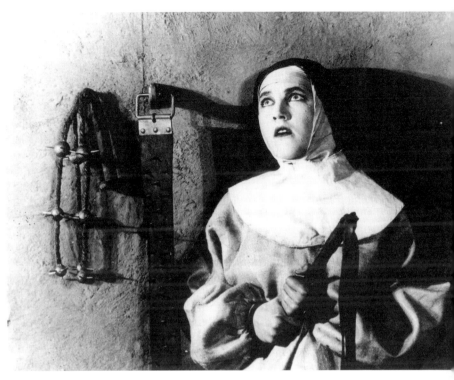

A nun driven to masochistic fantasies by her belief in the Devil.

Elith Pio (a monk): *My memory of those working days is still crystal clear and that owes to the fact that we were so very inspired. Benne was so tremendously inspiring, and it was clear to many of us that this man we worked for was ahead of his time. However I'd be exaggerating if I said the filming was idyllic. It was anything but, especially for me, a sinner who had forced himself on a young virgin and therefore had to be whipped – and whipped I was, emphatically – by the monk, Aage Hertel. That was a veritable thrashing he laid down upon my naked back... Unfortunately we only got to see the scenes*

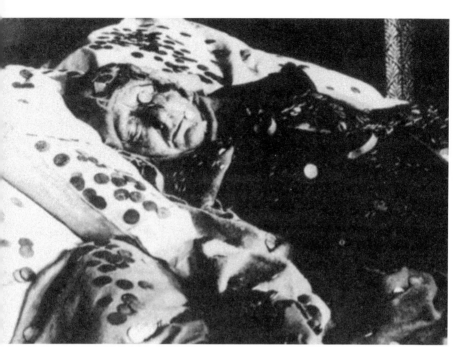

A greedy old hag gives herself to the Devil and is rewarded with gold coins.

we were in, and one was only able to move about the studio in the most clandestine manner. But one day I managed to sneak away and see some of the other scenes being shot, including one where Benne was playing the Devil. I must confess his performance gave me a shock. That was unforgettable!

Astrid Holm (Middle-class woman): *I remember that everything that took place out there was very daring. I suffered the ravages of all possible types of torture instruments, was dragged off by brutal hands and eventually met a painful death! It was very exciting to be part of a film that aimed to do more than just entertain...*

Aage Hertel (a monk): *In the searing summer heat, wearing a wig, I played a number of roles in* The Witch. *I was the monk with fangs and the Devil with a rubber mask, etc. It was frightful!... I suffered it all for Benne's sake. The stuff with the mask was the worst... it was glued onto my face in a distorted fashion and when they took it off the first time my skin came off with it. Around my eyes was just bloody flesh.*

Alice O'Fredericks (a nun): [O'Fredericks was an office girl who had run an errand out to the studio and was spotted by Christensen, who had her do a screen-test. –ed.] *That was my first role. I was 17 years old and involved in that shocking scene in which 30 to 40 nuns went amok! Once I got over the first difficult period of shyness, I aggressively threw myself into the spirit the part demanded and screamed the profane curses. Afterwards, when we were all level-headed again, we found it all to be extremely upsetting. We were really bizarre.*

Emmy Schønfeld (a witch): *I played a witch who was in love with the devil and in a dream I got a pile of gold. Yet my best – and worst – scene was when I flew up through the chimney! Even though on my flight through the sky I was aided by special effects, it was not a pleasant experience to be bound with a strap around the waist and hoisted up under the ceiling of the studio. When I think back to that scene, as the belt was tightened and cut into me, the pain returns... Those were strange days out in Hellerup, not least to suddenly one day find the wooded grounds of the studio transformed into a witches' lair. They did that by digging up all the trees and then planting them again upside-down so that the roots were sticking out into the air. The memory of that sight still makes my heart pound. The grounds looked spooky and fantastic after the 'operation.'*

Ib Schønberg (a monk): *Christensen ordered me to go to the barber in Hellerup who, to my family's horror, 'kronragede' me!* [given a monk's haircut, bald on top]. *All for the sake of art. I was after all only 17 years old and found it all to be a great, almost supernatural experience. And there I met Maren Pedersen whom I shall never forget. She was a wise and a nice person, but the memory I have of her is not the best; Benne had fashioned a leash on her leg which he pulled on as a means of getting her to move toward or away from the camera.*

Karen Winther (an accused witch): *It was a shock to go from Lau Lauritzen's cozy and cheerful farces at Nordisk Film to the Benjamin Christensen-esque nights where I performed amongst the most macabre props and settings. One day in particular I sat for 8 hours in a torture chair – and to be honest I wasn't worth much when I got out. Nonetheless it is an experience I recall only with fondness.*

Benjamin Christensen (The Devil): *It is a state of bliss for an artist once in his lifetime to get permission to do what he wants. That happened with* The Witch.

Christensen launched into the editing process that fall with some apprehension. How would the censors react to some of the more intense scenes? This was indeed frightful stuff. In the first sequence of the dramatic re-enactments that start chapter two of the film we see a couple of old witches cooking up a magic potion down in their subterranean lair in 1488 (a year after the publication of *The Witch Hammer*). One of the squat old hags extracts a rotting human hand from a faggot of sticks and snaps off a finger to use in her witch's brew. Later the gentle viewer encounters cannibalism, blasphemy, sex with

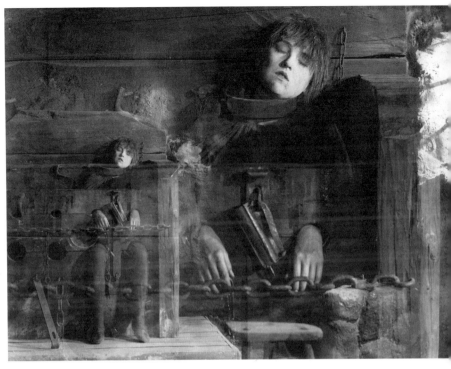

Actress Karen Winther plays the young woman who is accused of witchcraft and forced to endure the torture chair.

demons, adultery, masturbation, the cutting up of foetuses, and so forth. Deformities are displayed, torture devices are demonstrated. But for many the sex was the worst of it.

John Ernst, writing in 1967 while Denmark was in the throes of a sexual revolution, commented thusly on that aspect of the film: "In spite of the pedagogic way he presents his case, that [sexual aspect] can easily startle the modern viewer when they see this 1922 film for the first time, acclimated to pornography though they may be. In what other film does a scene take place where the beautiful young

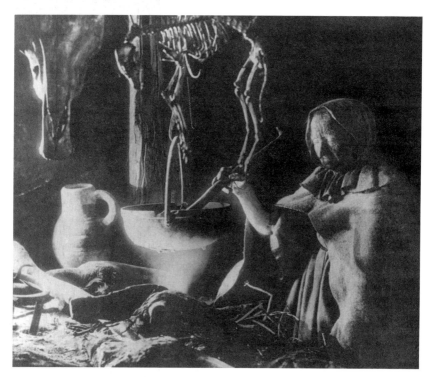

above: *An old witch prepares a love potion.*
opposite: *Witches kissing the Devil's arse.*

witches prance up to the Devil himself to kiss his buttocks?
When is the last time the reader has witnessed in a film a
scene where two old hags urinate into a pissing pot and heave
the contents against a neighbour's door? In what other film
are there so many images of sexual perversions, torture,
animal abuse, blasphemy and naked women?..."**32**

Christensen was pushing the censors into perhaps an
even more compromising position than he had forced the
beautiful young witches – he was forcing them to pass
judgement on something new. In Sweden they even called in

a couple of neurologists to sit with the censors deciding the case.

Early on in the process he had wanted to involve men of science in the project to give it the stamp of credibility, but this idea went nowhere because, as he would later claim, scholars wanted nothing to do with a medium as disreputable as film. Once his movie was completed he did manage to solicit testimony from a professor by the name of Johansen who gave it high marks and declared that he shouldn't take out a single frame.

Whether or not the 'worst bits' were edited out at some stage before or after Johansen passed judgement, as at least one commentator claimed, is impossible to know today, but considering what was left in it is hard to imagine what Christensen could have wanted to include that was more extreme. In any case, by the fall of 1922 the film was ready to play, sumptuously tinted in red, gold, green and, for night scenes, blue.[33] Divided into seven chapters, *The Witch* had a running time of 104 minutes, which was longer than average for feature films of the period.

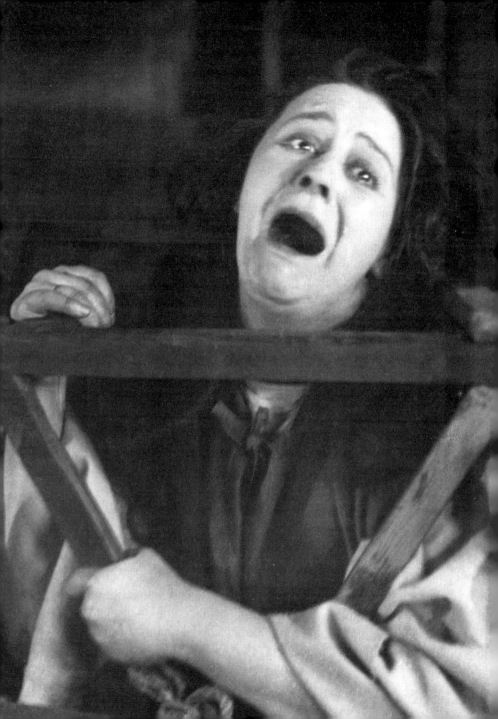

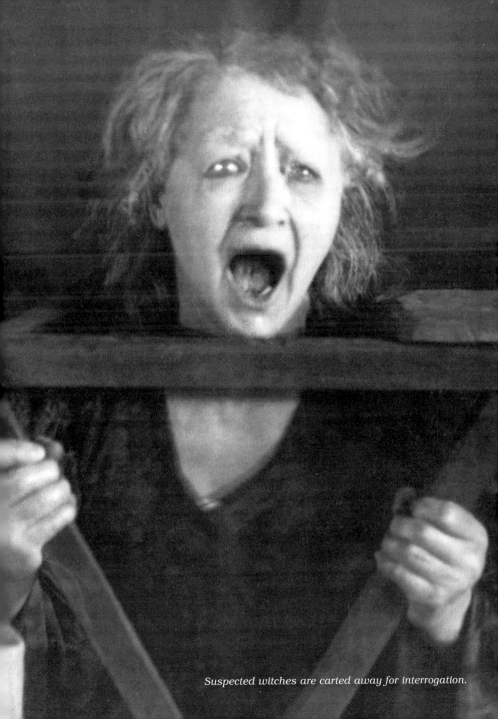

Suspected witches are carted away for interrogation.

Launy Grøndahl: Forspil til „Heksen".
Efter Pausen:
Launy Grøndahl: Mellemaktsmusik til „Heksen".

Paladsteatrets Films = Magasin
4. Aargang. Nr. 3.

Benjamin Christensen Filmen

„HEKSEN"

Kulturhistorisk Film i 7 Akter

Forfattet og iscenesat af Benjamin Christensen

I HOVEDROLLERNE:

Clara Pontoppidan	*Poul Reumert*
Astrid Holm	*Elith Pio*
Tora Teje	*Oscar Stribolt*
Karen Winther	*Aage Hertel*

Musiken ledet og arrangeret af Jacob Gade

Benyt **DET NYE REJSEBUREAU**
AXELBORG HAMMERICHSGADE — — TELEFON: 10632·

*Cover of an original programme for the Danish premiere of **The Witch** (**Heksen**).*

Public Reaction to 'The Witch'

The world premiere of *The Witch* took place in Stockholm on 18 September, 1922, with a print that contained at least two brief cuts, while the Danish premiere, which featured an uncut version, was held on 7 November at Copenhagen's Palads (Palace) Theatre where Christensen had marvelled at *Les misérables* seven years before. Originally the city's railroad terminal building, it had been converted into a grand movie theatre in 1912. With 2,300 seats, it was the second largest in Europe at that time and employed a staff of 100. Opening music composed by Launy Grøndahl played as well-dressed patrons took their seats. Once the auditorium was full, the carbon arc lamps in the giant projectors were lit with a hiss and the house lights faded. A brilliant beam of light sliced through the darkness to splash the first images onto the screen as the original score, composed and now conducted in front of a thirty-piece orchestra by Jacob Gade, majestically rang out.

The film began with a lecture by Christensen who stood by a pile of books – his sources. He then gave an encapsulation of the movie's theme. Filmed separately by another cinematographer, this opening was a unique way for the director to personally introduce himself to the audience. And then the film itself began.

Of all the scenes, the flight of the witches to Bloksbjerg received the heartiest applause, and at the end of the show there was a rousing ovation. At this point it would have been natural for Christensen to come out and take a bow but he was nowhere to be found. Before the show he had given instructions that a sheet listing the literary sources upon which the

film was based be placed upon every seat so that viewers might appreciate the research that went into the making of it, but as people were taking their seats he didn't see any paper. He soon discovered that the bales of notes had been tossed out into the back by the trash, and it was reckoned that he had stalked off somewhere in a rage.

Everyone seemed to agree that this was something new; a film that had nothing to do with love or intrigues, a film that had no heroes or plot in the normal sense, that presented no conflict to be neatly resolved by the last reel. A film that had no happy ending.

After that opinion divided sharply.

The most outspoken criticism was voiced by the daily, *B.T.*, as the following article from their 8 November, 1922 edition testifies.

TAKE THE WITCH OFF THE SCREEN

Benjamin Christensen's The Witch *was technically a masterpiece. But its topic was a fateful mistake.*

Hardly any other film in the history of Copenhagen movie-going has managed to attract such a prestigious audience for its grand premiere as Benjamin Christensen's The Witch, *the event having taken place yesterday at the Palads Theatre.*

Not only were all the VIPs of the Danish film and theatre world present, but the seats were also occupied by those from the most sophisticated and fashionable classes of society, and when the opening (news) shorts faded out and the overture rang out broad and majestically from the orchestra pit, an expectant shudder passed through the crowd.

Benjamin Christensen obviously knows how to arouse expectations to the maximum. For two long years the city has

been abuzz about The Witch. *Rumours have circulated about the insane cost of the film while contradictory stories about the scenes being shot inside the fortified confines of the Hellerup studio have been exchanged in hush-hush tones by word of mouth. At one point it was rumoured that an actress had refused to play the role the director had assigned her because she considered it an affront to her decency. Soon enough those kinds of rumours proved to be unfounded, and, to the contrary, the actors had performed under Christensen's leadership with enthusiasm and devotion.*

An alluring veil of secrecy was laid over the making of the film, and not even the cinematographers or the bearers of the big rolls of raw film stock perceived what they were really helping to create… They all just had a feeling that this was a completely different kind of film and that they were embarking on a journey into a new and mysterious realm that would lead to the rebirth of the art of cinema and mark the beginning of a renaissance in the medium.

Last night that feeling had transmitted itself to the audience who studied the first blue (tinted) texts with rapt absorption as they appeared on the distant screen, the first metres of this new work which would bring Benjamin Christensen victory or defeat.

Did he triumph?

He could have. There is no doubt that the broad public which the film medium has attracted is about to loose patience with movies – as this movie demonstrated. Time and time again the empty smiles of the audience indicated they were being bored by the empty sensations. A desire for a more weighty experience which would not just entertain but also enrich lay in the air. And Christensen's basic idea, to create a popular film lecture, an 'essay of the silver screen,' is undoubtedly an ingenious attempt to accommodate this desire.

He could have chosen to present one of history's great figures in a fashion not bound by standard film conventions but flush with the intensity and rich colours of the truth. He could have addressed a basic human question which lies in thousands of hearts and begs an answer. And with the great sums of money he had at his disposal, with all the technical expertise and the directorial mastery that The Witch bears witness to, he could have created a film which would have struck the audience as a revelation, opening up the doors of movie theatres to a new public...

Instead he has chosen to turn down one of history's dark side streets, taking up for consideration the subject of the Middle Ages' belief in witchcraft in order to compare it to modern superstitious tendencies. The basic error is not that the topic is distant and specific but that from first image to last it touches upon not only the hysteria of the times but also upon, as he himself terms it... the unvarnished perversity.

This is a chapter from the dark side of human history, a story of sickness that he chooses to delve into. It is no more appropriate to read aloud from the daily logs of an insane asylum for an evening's entertainment than it is to play The Witch for a large and varied public where youth is in the overwhelming majority.

Had Christensen said, 'I have the money which shall be used to make a film only intended to be screened for the scientifically educated, for the authorities and for seasoned professionals,' no one would object. It would stand as a bizarre but interesting experiment. But when he throws open the doors to the masses and shows it to the young women of the town and to office worker Hansen and his beloved under the guise of education, then one must protest, and in the name of film protest forcefully!

Witches' Sabbath on the Silver Screen

Let us take a rough look at Benjamin Christensen's film lecture.

It begins with classic documentation. We see on the silver screen not living pictures but woodcuts of scenarios from the Middle Ages which present the story of belief in witchcraft, while a pointer stick draws attention to various details. This is stern and straightforward stuff, no false advertising here. It is immediately apparent that this is no film in the traditional sense.

But suddenly the images come to life and the same situations told by woodcuts now flicker upon the stage in living re-enactments. Christensen has reconstructed the anatomy of a witch persecution from the Middle Ages. He shows how a whole village is gripped by hysteria. An inhabitant lays sick and of course it is assumed that he's been cursed by a witch.

A travelling witchfinder general arrives and examines the afflicted man, declaring that without a doubt his condition has been caused by a curse, and immediately a hunt is on for the witch. Naturally suspicion falls upon a loathsome old woman who comes around every day and begs at the door, a woman who gobbles away at her øllebrød [a porridge made of bread and non-alcoholic beer] with wrinkled fingers. [This was Maren Pedersen, and before she digs into the runny slop she puts a couple of fingers to her nose and blows a glob of snot on the floor. –ed.]

The sick man's daughter accuses the old hag of the heinous deed and she's dragged before the court and subjected to a painful interrogation. All the bestial torture instruments of the Middle Ages are applied right up there on the silver screen; thumbscrews, barbed neck bands, foot-crushers and fire. For over half an hour this orgy of sadism is celebrated up on the

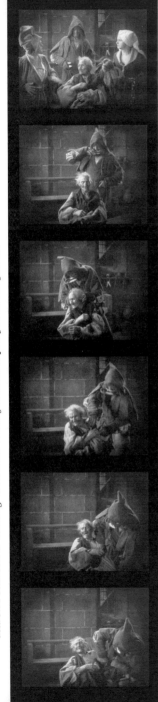

screen. *Metre after metre of film rolls through the camera, which is frozen on the old woman's tormented mummy-like face, boring in with shameless close-ups until the feeling of nausea overwhelms.*

Of course the old woman confesses to everything they've accused her of and more on top of it. In a series of pictures one sees the whole of the witches' Sabbath as their poor, sick, perverted brains conceived it.

The Bonfires Blaze

And it is supposedly not just this old woman who has been to Bloksbjerg, but all those that the daughter hates, including the cow that kicked out at her as well as two old women who had practiced their unappetizing art [of throwing the contents of piss pots at their neighbour's door] *– all have participated in that wild dance around the old devil.* [The wording here is somewhat confusing: it is actually Maria, under torture, who names practically everyone she knows as co-conspirators. –ed.]

The Judge believes every word she says.

Bonfires blaze over the whole town and the judge himself feels plagued by the Devil's hand-maidens. A young handsome monk has felt a sting on the wrist where a beautiful young virgin has grabbed him, and to make the burning sensation go away he has himself whipped, but the fire cannot be extinguished by the lashings. The virgin is therefore a witch. Before we witnessed the old mummy-like woman being tormented, now it's young female flesh and body parts that are flayed while she is broken on the wheel before our eyes.

It is true that these things happened, God help us, but – hand on your heart – which instincts are aroused in a large and diversely composed audience by this kind of brutality when it is inflicted upon a young, undressed actress?

The dance of the witches continues. The nuns are gripped by a mysterious hysteria in front of the altar... the devil lays himself down between married couples in their beds. He is everywhere and all hearts pound in fear at the prospect of meeting him in the flesh on the next street corner or in the next room!

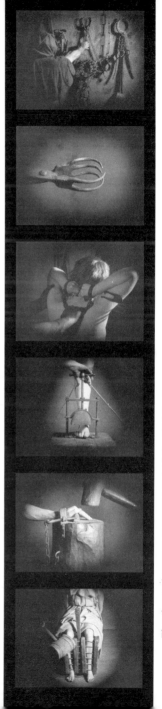

The 'bestial torture instruments' of the Middle Ages.

The Embarrassing Ending

Finally Christensen draws his conclusions by advancing a theory.

The belief in witches has passed but the superstitious tendencies that nourished it live on. The existence of fortune-tellers, kleptomaniacs and hysterics of every stripe is but a modern echo of what the ignorant souls of the Middle Ages were possessed by, but it is in this concluding chapter that Christensen suffers his biggest defeat from a purely artistic standpoint, in the process casting doubt on the seriousness which lays behind this gloomy film. The scene suggesting that today the airplane has replaced the witch is but an insipid witticism, and at the end when he presents us with the modern version of the witch who once burned on the bonfire but is now a fashionable young kleptomaniac [kleptomania = compulsive behaviours = witchcraft –ed.] *pictured undergoing therapeutic shower treatment at a nerve clinic – this left one sitting there not with a bad taste in one's mouth but with an embarrassed taste.*

The Undressed

Nudity is plentiful in Christensen's film. The screen flashes with the white flesh of bare backs and naked silhouettes wandering in the secret lairs of the Devil's realm. But it is not the nudity which is most offensive about the film. It is the Satanic perversity and gruesomeness which leaps from it like flames, a kind of unfathomable, plumbless evil – humankind's chimera – that everyone knows has existed down through the ages. But when that is caught and fenced into a cell, whether that be in a prison or in a madhouse, it is not to the accompaniment of Wagner and Chopin, nor is it in front of a fashionable public

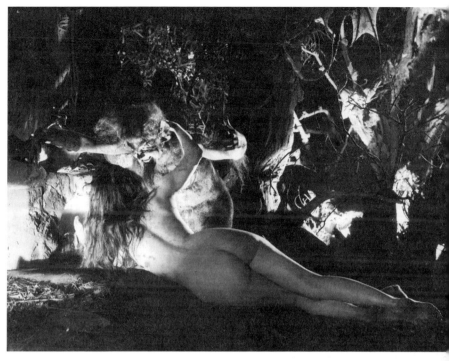

A beautiful young witch-to-be gives herself to the Devil.

seated in comfortably upholstered movie seats. It is not for the young men and women who have ventured into the magic world of the movie theatre.

 If that was 'Mr. Anyone at all' who made this film then we could respond with a kick or a shrug. But that person is Benjamin Christensen who, even with this major mistake, proves that he is one of the few upon which Danish film can build its future. And then it becomes a different matter. We can therefore end this review in no other way than to voice deep regret that he has allowed his considerable abilities to lead him into this blind alley.

(One can only hope) that he will find his way back into the light again as quickly as possible and create that great popular film that will do justice to his talents.

But regarding The Witch *we ultimately have but one request; take it off the screen as fast as possible!*

Debate about the film continued to rage in the wake of the premiere, and on 9 November *B.T.* elaborated on their concerns in a follow-up piece.

FILM AND POPULISM

While B.T. stood rather alone among the city's press in its appraisal of the new Benjamin Christensen film, The Witch, *we have in turn received considerable proof that our evaluation of the movie was in accord with what many of those attending the premiere thought. And the question we are constantly asked is this; how in all the world has this film been able to pass the censors?*

We would on this occasion draw attention to the fact that we are not among those who constantly cry out for the censorship of film. We have also not taken that position in this case since we understand the censor's viewpoint in letting the film pass. They must also once in a while show a bit of courage. And, after all, it is not the acting in this film that exploits the viewer's basest instincts. The Witch *is a deeply serious work, written and staged by an artist who undeniably occupies a leading position in his field, who consciously and manfully has fought against the emptiness and sterility that characterizes so many films and who has pioneered new modes of expression in the medium.*

We understand the motives of the censors who refused to prohibit the film in advance, they having no desire to quash

Christensen's attempts to create something new. With that said, we must protest that this film is now, evening after evening, attracting a sensation-seeking public. The task that Christensen has set himself is to solve or explain a cultural-historic problem or situation through his art. We believe in the future of film and we also believe that the medium as such will begin to address itself to these [cultural-historic] issues. But film is and will always be a popular medium, an art form for 'the people.'

As we previously wrote, 'It is no more appropriate to read aloud from the daily logs of an insane asylum for an evening's entertainment than it is to play The Witch *for a large and varied public where youth is in the overwhelming majority.' This is precisely the core of the case. We have no doubt that the director of* The Witch *will be able to produce laudatory quotes from renowned psychiatrists and history professors in his defence, but the (professional) views these men take on the unflinching sadism, the torture and the nudity – and all that occurs during the wild and appalling witches' Sabbath – has no relevance to how the broader public, not least young viewers, will relate to the film. With the general public there is no understanding of cultural-historic context and no knowledge of psychiatry is brought to bear. The film arouses a different set of instincts in the general audience, and this kind of attraction we can best do without.*

When one lectures to a general public and attempts to teach them about the darkness of ancient times, one assumedly does so without unveiling a series of exhibits which drip with blood and border on the pornographic. One must trust that said lecturer has the ability to reproduce these images in such a way so that they do not disgust or titillate the audience.

Benjamin Christensen lacks this ability – and he has caused grave offence. To his mind conveying the truth about the subject

is synonymous with presenting it in the most harshly realistic
terms. Well, no one can prevent him from having that perception,
but in so doing he has forfeited the right to deliver his lectures to
a broad public. And no one can deny that the film theatre
attracts one of the broadest publics in our country. One should
not be nauseated or titillated in a movie theatre. One should be
entertained or preferably educated, or in best case elevated.

One might have expected the censors to be conscious of this
to a somewhat greater degree, and maybe to have hit upon a
compromise solution that would have pre-empted the sensation-
alism and morbidity that took complete possession of this film.

The daily paper *Social Demokraten* agreed that it was all just
too much. "Many of the images exude such raw realism that
the dominating reaction is one of nausea... the viewer suffers
the torments along with the victims on the screen. The film
seems itself a product of the beastliness, torture, bonfires and
insanity that it means to critique. Even Griffith and his staff
could hardly have created anything like that."

The case that *B.T.* makes against *The Witch* reads like a
textbook definition of 'exploitation cinema' that would come to
flourish in America in the Thirties, the *modus operandi* of its
progenitors being to crassly and with premeditation – and
definitely for profit – palm off lurid spectacle on the public
under cover of providing enlightenment and edification.
Censors were prone to be more sympathetic to films that had
moral or educational intent, and rogue producer-directors
tried to have it both ways: they loaded their cheaply made films
with sex, violence, nudity etc. to attract the paying public, but
larded it all with sanctimonious moralizing to placate
puritanical elements of the public (who were hostile to movies
to begin with). Hollywood itself employed this strategy via what

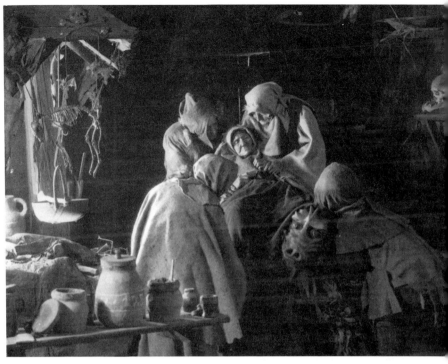

Maria the weaver (Maren Pedersen) confesses under torture that she gave birth to demons.

would come to be known as "compensating moral values," meaning that the bad guy could have all the fun and sex he wanted in the first nine reels but he had to pay for it in the last reel, usually by dropping dead in a hail of bullets. Bigger-budget Hollywood productions conveyed this via action while Poverty Row producers who could hardly afford much 'action' conveyed it in the tone of their films.

Christensen was clearly anything but a fly-by-night 'exploitationist.' He was an artist and a master craftsman and *The Witch* was a true work of obsession, not just some hoary

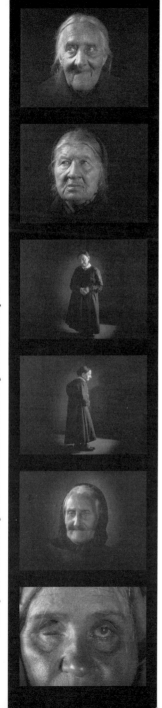

attempt to separate the customers from their hard-earned money, but his motives remain in question. He liked to see himself as a man of science and rationalism, but he was also drawn to sensational subject matter. With *The Witch* he was attempting to show how ridiculous and horrible primitive superstitions were. "The belief in evil spirits, sorcery and witchcraft is the result of naïve notions about the mystery of the universe," he would say. But he still made it all appear very intriguing, mysterious and scary and filled the screen with beautiful semi- and not-so-semi-naked women. As has been shown, this struck some as dishonest and exploitative. Was this education or entertainment or just pure salaciousness? Or something infinitely more sinister? And the shots of deformed women he included in the final chapter (a hunchback and a woman with a facial deformity in close-up) had a startling impact, however briefly presented.

He had his defence down pat. The film had a moral and that was contained in the concluding 'modern section,' which aimed to show how susceptible modern man still was to

the seductions of the 'dark side.' While many thought this the weakest part of the film, it served an important function. There was no human villain to be shot dead in the last reel, but it held out the prospect that there was a constructive lesson to be learned from it all. This was the film's official *raison d'être* and many bought it and figured Christensen was entitled to some dispensation. As one writer put it, "...consideration for the modern public's aesthetic feelings must yield for more important considerations, and the censors have naturally permitted scenes which otherwise would have been unthinkable."[34]

Other reviews of *The Witch* at the time were more mixed than the 'attack' published in *B.T.*

Politiken praised the photography and the acting, while *København* pointed out that Christensen had rendered the public a service by revealing that movies were more than just acting and (filmed) novels. "*The Witch* was an unconditional success," stated the latter publication, "but will it become a success with the public? This is perhaps more in doubt. Many will come because they are attracted by the sensational subject matter and the artistic quality of the film, but one doesn't get people interested in (cultural) history just because it's shown on film. All in all a strange evening which in many ways points to the beginning of a new direction in the film medium."

A more positive if still mixed appraisal of the film was offered up in the daily *København* on 9 September, 1922:

THE WITCH AND THE OTHERS

The premiere of The Witch *at the Palads Theatre has given rise to a lot of shouting. So much so that some voices have grown hoarse from shock over specific images contained in the film. It*

is possible that one scene here or there could have been cut out, even if they were just as historically accurate as the rest. We shall not become embroiled in that feud but would just point out that in any event the film is a serious work which cannot be measured with the same yardstick one uses on an American beach-comedy. And finally, before one gives voice to outraged protests, one ought to think about what we have put up with over the last decade when it comes to films full of affectation, mushy sentimentality and sleaze, and which perpetuate fraud on the silver screen, consciously and unconsciously. We have viewed and thereby supported thousands of really unhealthy films. Let us embrace the attempts that are made to find new ways and new directions forward for cinema.

The public was apparently just as divided as the press, the tumultuous applause at the end notwithstanding. Crowd response is a strange thing. Perhaps doubters just got swept along in the spirit of the moment, and there were indeed doubters, as the 9 November issue of *København* attested.

IS THE WITCH A GOOD FILM?

As expected, the premiere of Benjamin Christensen's The Witch *took place in the 'Sign of Sensation.' But some in the audience were also shocked and/or offended. As far as one could determine the reaction of the public was very much divided. The audience was certainly not completely 'with' the film. We have asked a couple of people who were there what they thought about the film and this is what they told us:*

Director of the Royal Theatre, Poul Nielsen, finds The Witch *highly interesting:*

I rarely go to see movies but I'd heard so much about The Witch *that I had to go see it. I must say straight off that I found it a highly interesting work. Benjamin Christensen is a peculiar and ingenious fellow, and his ability to get things done is rather amazing.*

Take for example his working methods. He finds an elderly woman who probably has no conception of how to act. She is subjected to torture while in reality she merely moves her mouth, muttering incessantly. But nonetheless the director gradually manages to arouse her sense of fantasy and her eyes acquire the appropriately spooky expression.

(Naturally) it is true enough that the topic can be 'perverse,' but the director – the lecturer – cannot be held responsible for the fact that back in the Middle Ages these things were being set in motion by people with perverse imaginations. It is wrong to accuse Christensen of wallowing in sensationalism.

Professor Viggo Christiansen, Dr. of Medicine, finds the parts on the Middle Ages excellent, but he misses a witch-burning.

That's nonsense when people claim that there is exploitation at play. The Witch *is excellently made. And furthermore I've been told that the 'worst bits' were cut out. It's stupid to talk about sensationalism – that hasn't at all been the approach Christensen used. Had that been his intention, there were stronger things in his source material he could have chosen to bring forth.*

I think that the scenes of the Middle Ages were in all ways excellent. They were authentic renderings of works that can be found, for example, in the Bibliotheque-diabolique. The only thing I missed was a real witch-burning. And he could have easily shown us that. [Bodies do dangle on a bonfire in the last shot –ed.] *The modern part I did not so much care for.*

I consider The Witch *to be an historic film which has succeeded in reproducing the atmosphere and details necessary to give us insight into the psychology of those times.*

The Witch was apparently successful enough with the public in Sweden and Denmark. Swedish reviewers, however, took a dim view of it until an influential commentator by the name of Dr. Fogelquist, a man who was normally no fan of the film medium, praised it in a widely read article in *Dagens Nyheter* and turned the tide of critical opinion in its favour – although it was reportedly thereafter banned for many years. Or was it simply forgotten? In any case it proved to be the kind of financial disaster the studio didn't need at a point when admissions were already declining and Hollywood was becoming more competitive.

In other countries *The Witch* proved much more problematic.

Eight-thousand Catholic women protested in the streets when it finally opened in France in 1926, demonstrating against it outside the Paris theatre where *La sorcellerie à travers les âges*, as it was titled, premiered.[35] In a complaint to the police they claimed that it was immoral and a mockery of the Church. "The French press kept their distance from the film," noted a Danish writer at the time, "its exhibition sparking a wider debate about the screening of foreign films." Parisian surrealists liked it better and it became one of their favourites.

In English-speaking countries no one dared show the film for many years. In America the New York censorship committee screened it for a select audience of cultural movers and shakers, just as they had for *Blind Justice*, but *The Witch* was infinitely more controversial and the chairman of the

Poster for a French theatrical re-release of **The Witch**.

committee was fired because of it and Christensen was asked to vacate the hotel where he was staying.[36]

Over the decades the Danish press would often refer to the quote in *The New York Times* that stated that the film was "25 years ahead of its time." The actual wording, however, is somewhat more ambiguous: "Come back with your film in 25 years, Mr. Christensen, and maybe then America will be mature enough to understand your art."[37]

In Germany the film fared somewhat better. Erich Pommer, head producer at the all-powerful UFA studio, was a big fan and arranged private screenings of the uncut version for various groups of artists and scholars who responded very positively.

Average Germans only got to see a much more edited-down version when it opened there in June 1924, the result of long negotiations between Christensen and German Catholic groups that reportedly only left the 'torso' of the film intact. Nonetheless it played successfully in that country for months.

Pommer held the film in such high esteem that he invited Christensen to come to Germany and make movies for his studio. The Dane eagerly accepted. The two follow-ups he had envisioned, *Helgeninde* (*The Woman Saint*) and *Ånder* (*Spirits*) were now out of the question. (Magnusson had made him an offer to direct eight more pictures but he had declined, refusing to be involved in 'assembly-line productions.') And, since no Danish studio wanted him now, Pommer's offer was timely. "After *The Witch*," Christensen would recall, "I was out in the cold for two years. When I finally got a chance at UFA, I had to disprove that I was this 'literary experimentalist' that everybody said I was, and so I made these purely commercial films.'[38]

The German and American Films

Christensen's first 'purely commercial' film for UFA was *His Mysterious Adventure* (*Seine Frau, die Unbekannte*), an unevenly realized marital comedy that was both farce and melodrama and came complete with a happy ending.

Nevertheless it displayed flashes of Christensen's visual inventiveness. Opening in Berlin in October of 1923, knowledgeable viewers could appreciate the typically Christensen-esque erotic component that included a fantasy sequence in which a wife imagines what her husband is doing with another woman behind closed doors. This prompted at least one Danish critic to complain that he had "succumbed to the temptation, as he had in *The Witch*, of investing his greatest efforts on a series of scenes that pander in rather embarrassing fashion to the unsavoury."[39]

He then took temporary leave of his directorial duties to act in Carl Dreyer's psychological drama, *Michael*, which was also being shot in Berlin. Based on a turn-of-the-century Danish novel of same name by Herman Bang, it was the story of 'the Master,' an elderly artist (played by Christensen) whose feelings for a young protégé are ultimately betrayed.

Christensen and Dreyer were two very headstrong individuals, with Pommer, among others, predicting they would clash on the set – and they did. An article on the shooting relates how they agreed not to call each other "idiot" since that was a word the non-Danish personnel could understand.[40] But the results were extraordinary, prompting effusive praise for Christensen's performance in a film that Dreyer would always consider one of his best.

This afforded some small measure of vindication for Christensen after *The Witch*, which had quickly come to be considered a fiasco, and no doubt it was an ego-boost for him to see posters billing him as 'the Master.' 'And yet,' as Casper Tybjerg notes, "...there is something eerily prescient about having Christensen play an artist whose best work is behind him and who dies a bitter man."[41]

His next film for UFA was the English-spoken *The Woman Who Did*. It was based on a book that the British novelist Grant Allen had published in 1894. Allen had availed himself of the opportunity to weigh in on the debate about 'free love' that was then abroad but, despite dealing with the controversial subject of a woman who chooses to have a child outside marriage, this was no hard-hitting exposé and in later years Christensen was wont to dismiss it as lightweight fluff. There were other problems as well. The international cast of Brits, Yanks, Russians and Germans not only lacked chemistry but could barely understand each other. As he later wrote to a friend, "...none of the actors spoke the same language and just pranced gaily around each other, and after having spent the first day acting as an interpreter, I gave up. The film had to be made quickly and I ended up just letting them say what they wanted. It was a tower of Babel."[42] He even sent a telegram to the backer in London advising him to abandon the project, but to no avail.

The Woman Who Did opened in December 1925 to dismissive press. Christensen himself was more uncompromising in his assessment, going on to call it "the greatest... fiasco of my life, and the only film of mine I never dared to actually watch after I shot it."[43] As to whether it was really that bad, today it must remain an open question since it figures among the many 'lost' films of that era.

While Christensen had departed for Germany, a fair number of his Scandinavian colleagues had chosen to set sail in the other direction – to Hollywood. Among them was the Swede, Victor Sjöström, who had gone to work for MGM (his last name Americanized to 'Seastrom'), for whom he directed the studio's first real hit in 1924, *He Who Gets Slapped*. He managed to persuade Louis B. Mayer to view a print of *The Witch*. Mayer was impressed with what he saw but also clearly taken aback, wondering aloud as to whether Christensen was a genius or a madman. (The Dane would quote this remark over the years with a certain ironic pride.) In any case Mayer sent Christensen a telegram offering him a contract at MGM and he accepted.

In February of 1925 he arrived in Hollywood. This sojourn effectively put an end to his second marriage, to Sigrid Ståhl whom he had wed in 1922 (although they would not formally divorce until 1934). But lonely in this new town he definitely wasn't; a sizeable Scandinavian expat community that included the likes of Sjöström, Stiller, and a young Greta Garbo already existed and he quickly became an active part of it.

His first encounter with the Hollywood studio system was a bit of a shock. As he would recall: "On the way over to America I'd gotten the idea for a film called *The Light Eternal* [*Det evige lys*]. I had most of the story in my head when I arrived. I described it to one of MGM's supervisors, Mr. Harry Rapf. He was so enthusiastic that he wrote me out a check for 5,000 dollars and told me to go back to my hotel room and write the whole thing down. As I sat there in front of the typewriter I realized to my horror that I couldn't recall essential aspects of the story. The check began to burn a hole in my pocket so I managed to think up a new story on the same topic. Twenty-two highly paid writers who had achieved great

success in the worlds of literature and the theater and who were now employed by MGM worked it over. Some months later it was finished. Now it was called *The Devil's Circus* and of course I couldn't recognize it at all. I told them that it would be the greatest fiasco of all time. All of Metro's bosses laughed at this idiot who believed he had directed a fiasco."[44]

Cold comfort though it must have been, Christensen was more or less correct, at least as far as the critics were concerned. Although some praised its atmosphere and photography, they generally dismissed *The Devil's Circus* as melodramatic, old-fashioned and lacking the subtle touch.

The studio writers had fashioned it into a romantic drama set in some unspecified (but clearly German-resembling) European city in order to capitalize on Christensen's – Americanized to 'Christianson' – 'exotic' foreign origins. (MGM would promote it as 'the first production in America of the European film genius, Benjamin Christianson,' and *Variety* agreed, calling it 'foreign and different.')

The plot centres on poor, friendless Mary (played by Norma Shearer) who encounters Carl, a petty criminal with a record. He has lecherous intentions but is disarmed by her innocence and vulnerability and they find solace in each other's company. Their happiness is short-lived when Carl is arrested again. Mary, however, has managed to change him and as the police drag him off to jail he promises to reform.

In the meantime she finds employment in the circus as a trapeze artist, but things take a violent turn when the lion-tamer takes a fancy to her and rapes her one night in her wagon. This sends his girlfriend into a jealous rage and she secretly loosens the ropes of the trapeze, causing Mary to plummet to the ground during her performance – and into a cage full of lions. She is pulled out alive but has been crippled for life.

The Great War is now raging. Carl has been released from prison and joins the army. Upon being discharged he returns to the city and becomes a cobbler, having made good on his vow to go straight. He accidentally runs into Mary again, a cripple now forced to sell string puppets on the street. (The puppet theme is established at the start: "When the devil pulls the strings, all the world must dance,' the opening title plate reads. Cut to a grinning devil figure who functions as a kind of 'master puppeteer.') Deeply distraught by her tale of woe, Carl sets out to find and kill the lion-tamer. But when he discovers the terrible fates that have befallen Mary's tormentors he can only conclude that his work has already been done for him: the lion-tamer has been blinded in the War and his girlfriend, sent to prison after causing Mary's fall, is now a prostitute. Together again – on Christmas Eve, no less – Mary miraculously begins to walk.

The film was Shearer's big breakthrough and did more for her career than Christensen's. According to him the studio was dead set against casting her in the lead and Irving Thalberg had even warned him that if he did it would be 'his funeral.' Later on he overheard Thalberg concluding a phone conversation with a tender goodbye to 'my beloved Norma.' Some funeral, he thought.

Despite the indifferent press the picture did okay with the public. It appeared to hint at better things to come for Christensen and won him some respect in the Industry.

Life in Hollywood, on the other hand, presented a series of more prosaic challenges as the dashing Dane tried to fit in. The most insignificant things could tag a man as an outsider. For example, he preferred to get his shoes re-soled instead of going out and buying new ones, but in class-conscious Hollywood this was a no-no: a successful director could not be seen tramping around in re-soled shoes.

His reputation took a rather more severe beating when two employees died on him. "...I had the cursed luck," he remembered, "that two men who were to work with me on one of the first films both went out and broke their necks in the same week. For some time thereafter I felt people were keeping their distance from me, and Larry Barrymore told me that it was obvious why no one would work for me when my employees were dropping dead."[45]

He also managed to make enemies without even knowing it. "At another point I got one of Hollywood's most prominent fortune-tellers on my back. He advised everyone to stay away from me because I only brought misfortune. Later on it turned out that he was against me because I had purchased an antique Chinese figure that he himself had wanted to buy."[46]

Christensen seems to have been a defiant figure at MGM and it no doubt irked some that a foreigner who could hardly speak English[47] could lay claim to knowing the tastes of the American movie-going public better than his bosses at the studio, even if he had had success in the country with previous films. On the other hand it must have been hard for Christensen to submit one story idea after another only to be asked in deeply sceptical tones if he thought this was something 'the American farmer' would go for – and then be told to forget about it as fast as possible. He was getting a crash course in hardball, bottom-line American capitalism.

But he himself was a battle-tested salesman, having schlepped potatoes, champagne and even his own early films. Even as MGM's writers were hacking apart *The Light Eternal*, he was exhaustively studying American movie-going habits, watching innumerable films and gauging audience reaction. Harry Rapf himself had to concede that he had gained "a better conception of those things than some domestic directors."[48]

Still it was something of a pitiable situation. *The Witch* had been a triumph of one man's vision, the product of obsession and the refusal to compromise, and now the same director was slavishly attempting to cater to 'the American farmer', no less. What Christensen might have achieved had he been encouraged to stay in Denmark and been given creative freedom on his pictures would occasion much soul-searching in Danish film circles in the decades to come. Truth be told, however, Denmark was too small to accommodate his grand ambitions (or ego) and Danish studios were incapable of producing the world-class epics that he could only make in Hollywood.

...An epic like *The Mysterious Island*, which was to be his next project. This was a loose adaptation of the Jules Verne novel, which MGM was prepared to dump a vast amount of effort and resources into. He took over the picture from Maurice Tourneur on short notice in the summer of 1926 after the French émigré had been fired by Mayer for objecting to the presence of a producer on the set who was constantly looking over his shoulder. By this point the studio had already sunk considerable sums into the film and Christensen proceeded to further drain their coffers by spending 300,000 dollars on the construction of a pool where the underwater photography for the prologue would take place.[49]

He threw himself into the production, directing during the day and feverishly rewriting the script at night, twice calling a halt to filming to work out story problems.[50] But bad luck struck again when a hurricane hit the Bahamas where location shooting was taking place, destroying the underwater sets and second unit equipment. The film was temporarily shut down and Christensen was given new assignments.

Lucien Hubbard eventually took over the picture. He largely recast it and had it ready for release in 1929. A writer later remarked that in his years at MGM Christensen had only managed to direct "two movies and one prologue," yet Arne Lunde suggests that Christensen's influence can be seen in more than just the opening: "...one torture scene of the young heroine suggests the macabre imagination of the director of *Häxan*. Silhouetted lighting in a submarine interior shot also shows traces of a key Christensen stylistic signature."[51]

Suffice it to say, Christensen's involvement with the film did nothing to help him shed his reputation as a squanderer of time and money.

With his next picture, *Mockery*, there seems to be some indication that MGM gave him a freer hand; it was based on his own original screenplay which the studio meddled with less than usual, and they gave him his own name back, billing it as a 'Benjamin Christensen production' – rather than 'Christianson.'

A romantic adventure set during the Russian revolution, it starred Lon Chaney as the simple-minded peasant, Sergei. He meets a poor woman in the woods but she is really the Countess Tatiana in disguise, fleeing an unthinkable fate at the hands of marauding Red soldiers. He agrees to escort her through enemy territory by pretending to be her husband, but

Witchcraft Through the Ages

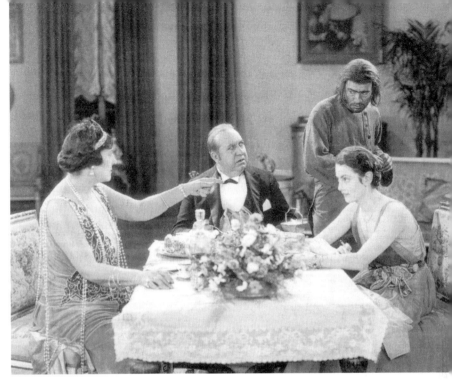

above: *A scene from* **Mockery**.
opposite: *Benjamin Christensen as he appeared at his peak in Hollywood.*

the ruse fails and they're captured by Bolsheviks. Sergei is tortured but refuses to reveal Tatiana's secret identity. Eventually they are saved by the dashing Dimitri (played by Ricardo Cortez) who commands a White Russian cavalry unit, and as a reward for his heroism Sergei is made a servant in the house of a wealthy war profiteer.

Tatiana and Dimitri fall in love while Sergei looks on with bitterness. He feels the noblewoman is looking down her nose at him. During a peasant uprising he attempts to rape her, drunk on liquor and Bolshevik propaganda. The revolt is put down by Dimitri and his troops. Sergei is however spared when

Tatiana swears that he had actually protected her. Soon another uprising occurs and Tatiana is again in mortal danger, but this time Sergei, now bound by eternal gratitude, lays down his life defending her.

The movie was energetically promoted. "Benjamin Christensen," touted the studio, "is one of the world's greatest authorities on the psychological effect of light and shade in the drama." The film's "many strange effects... worked out on the screen for the first time" constituted a "blending of American and European methods."[52]

Released in August 1927, it suffered an only slightly more merciful fate at the hands of critics than Sergei had at the hands of his attackers. Its setting, they claimed, lacked credibility. It's easy to see why: it had obviously been shot in Southern California, not Russia, and that was evident in almost every frame. Cortez's Latin appearance struck another off-key note.

Christensen's big mistake, however, was to cast Lon Chaney in a sympathetic role. Through a series of films like *The Hunchback of Notre Dame*, *The Phantom of the Opera* and Tod Browning's *The Unholy Three*, he had cultivated a sinister and sadistic persona which had won him adulation and given rise to a popular saying of the time: "Don't step on that spider – it could be Lon Chaney!" Viewers now had a hard time accepting him as a devoted and suffering victim. And though some critics praised the subtlety of his performance, 'the farmers of America' were up in arms about it, and according to John Ernst, "they sent threatening letters by the thousands to MGM."[53]

The failure of *Mockery* was another nail in Christensen's coffin as far as the studio was concerned, and it's no surprise that when he later approached them about terminating his

contract they could be persuaded. He thought he could do better at another studio, and in March 1928 he signed on with First National Pictures to make a single film. He would work in collaboration with his good friend, the author and critic Wid Gunning whom he'd first met in 1916 in New York while negotiating the rights to *Blind Justice*. It was Gunning who penned the original story upon which this film, *The Hawk's Nest*, was based.

The two of them had assembled a crack outfit that counted, among other able technicians, cameraman Sol Polito who would later go on to work with directors such as Michael Curtiz and Mervyn LeRoy, and they had the studio's biggest star, Milton Sills, at their disposal. Nevertheless this was a considerably less prestigious studio than MGM and *The Hawk's Nest* was what was known as a 'programmer,' a kind of B-movie. So be it. From all evidence Christensen was happy enough. And the story, set in the mysterious urban catacombs of Chinatown where shadowy characters appeared and vanished at will, allowed him to indulge in the kind of Gothic atmosphere of which he was so fond.

This was the shadowy domain of 'The Hawk,' a disfigured war veteran who runs a nightclub. Nearby is another neighbourhood hot-spot run by the gangster Dan Daugherty. In a diabolical twist the Hawk's best friend is framed by Dan for a murder he actually committed, and an innocent man is sentenced to the electric chair. The Hawk avails himself of plastic surgery and now, armed with a new face and identity, he proceeds to frighten the guilty party into confessing.

A review on 5 December, 1928, in *The Los Angeles Record* said in part that, "the direction of Benjamin Christensen is worthy of considerable comment due to the fact that he assumed a particularly mysterious style in handling his

characters. Odd [camera] angles are much in evidence, and for the first time it seems that Sills is listening to a director who has ideas."

The film was something of a hit and over the course of 1928 and 1929 Christensen and Gunning made three more movies with First National (which in the meantime was purchased by Warner Brothers), the Dane reinventing himself now as the can-do, go-getting 'Ben' Christensen, apparently in an attempt to dispel reports that he was unproductive, slow and somehow 'old world.'[54]

In 1927 Paul Leni had huge success with *The Cat and the Canary*, a 'mystery/comedy,' and Christensen now attempted to exploit the success of this popular new genre with a picture entitled *The Haunted House*. Here someone is trying to poison an elderly millionaire. Suspecting that it might be one of his heirs, he lures four of them to his seaside mansion by letting slip that half-a-million dollars is hidden there. Soon after arriving they begin to encounter a series of strange characters that include a beautiful sleepwalking woman, an insane doctor, his bewitched nurse and the inscrutable caretaker of the place. They're all frightened out of their minds and the would-be poisoner is revealed.

Christensen and Polito had used low-angle shots and inventive lighting to splendid effect while the performances of Flora Finch, Chester Conklin and Thelma Todd, who stayed on board for the rest of their First National comedies, won the hearts of audiences and ensured the film's success. And critics were kind enough, although nobody accused the film of attempting anything new. It was released in both a silent and sound version, the latter boasting audio effects that included slamming doors, gun shots, storm noises, groans and rattling chains.

Its success demanded a follow-up and that was to be *Seven Footprints to Satan* (1929), the only one of these First National films to survive, a print having miraculously resurfaced in the '60s. Like *The Haunted House*, this film was based on a novel (by Abraham Merritt), though Christensen found himself compelled to largely re-write the stories for the screen, working in both instances under the pseudonym of Richard Bee.

Seven Footprints to Satan was concerned with subjects Christensen knew about: superstition and Hollywood. The plot centres on Jim, a wealthy young man who imagines himself a great explorer. Together with his girlfriend Eve he plans a dangerous three-year excursion to the wilds of Africa; all of this against his uncle's will. But before they can depart they are kidnapped by unknown parties and taken to a mysterious mansion where a black-hooded figure called Satan presides. Here they are confronted by a procession of strange characters that include a bearded dwarf, a grotesque cripple, a sexy witch, a gorilla and what appears to be a werewolf. They witness shootings, whippings and so forth while hands clutch out at them and wall panels slide away to reveal secret rooms.

Nudity and orgies are also implied in a scene involving hooded men and unhooded women engaged in some kind of medieval-looking ritual (drawing comparisons to Kubrick's

Eyes Wide Shut) and who lie about on the floor in formal dress. A nude oriental woman is partially glimpsed in one short scene, a gorilla holding her feet while her wrists are tied above her head with leather straps. *Variety* described the film as "…unquestionably one of the hottest exhibitions of inequity done in a long while… no picture for kids."[55]

At the end of the film it all turns out to have been a ruse stage-managed by Jim's uncle to keep them from going to Africa (a premise and plot uncannily similar to the 1997 David Fincher film, *The Game*, that starred Michael Douglas.)

As both *The Witch* and *Seven Footprints to Satan* deal with superstition, contain racy scenes and make the most of spooky atmospherics, parallels are inevitably drawn. Although *Variety* had reviewed *The Witch* on 30 August, 1923, and called it "wonderful," it also deemed it "absolutely unfit for public exhibition." At that point in time *The Witch* had not even been released in America, and it wouldn't be until much later, and then only in a heavily censored version. (There is some confusion as to when the film actually opened in America. 27 May, 1929 is given as the date by some sources, while others say it was released in March 1930, and still other sources contend it premiered in 1932. Probably it had a limited early release in New York and 're-releases' elsewhere.)

There was some debate as to which Benjamin Christensen was pulling the strings in *Seven Footprints to Satan*. Was this the work of the sober-minded rationalist who took a dispassionate delight in revealing all this mystical hocus-pocus to be but the end product of human superstition, or were these simply the lurid excesses of the sleaze merchant that certain writers claimed to have caught not so fleeting glimpses of? The prominent Danish critic Ib Monty subscribed to the first line of thinking, convinced that Christensen was ridiculing

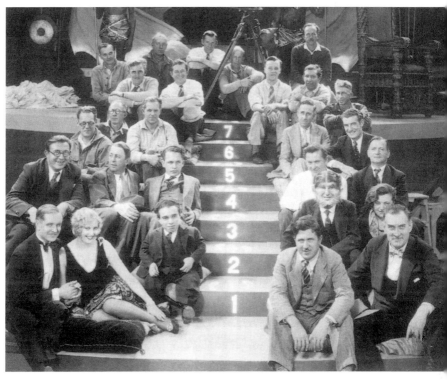

*Cast and crew of **Seven Footprints to Satan**: Christensen far right, lower.*

those predisposed to superstition (and perhaps also poking fun at the rubes of Hollywood who dwelt in a hopelessly provincial America).[56]

From a technical standpoint Christensen had once again shown that he was able to deliver chills and spills on a minuscule budget. He was also – as he had demonstrated in *The Witch* and other films – aware that actors who were immersed in their characters and fully understood the significance of their exchanges gave the best performances. And this very much involved *sound* – even in silent movies. In his early

A surprisingly thrilling picture play with—

THELMA TODD and CREIGHTON HALE

silent films actors still memorized and spoke scripted dialogue, and in these films viewers can often 'see' the sound even if they can't actually hear it. For example in *Blind Justice* a group of merrymakers listen keenly to the strokes of a clock as midnight arrives on New Year's Eve, while in *The Witch* the deranged mutterings of an elderly Maren Pedersen are perhaps even more affecting because we can only *see* her lips move.

During the shooting of *Seven Footprints to Satan* the movie magazine *Hollywood* noted how Christensen used sound effects even on the set of the silent version to motivate his actors and create the appropriate mood.[57] These sounds included gun shots, various types of bells, wailing sirens, the grating of metal on metal, groans, moans, screams and howls.[58] Apparently he had found a better way to communicate with his actors than in broken English – by screaming at them! And these sessions reportedly left him quite hoarse the next day.

The last of his First National films was *House of Horror*, the tale of a terrified couple trapped in a haunted house with a

killer whom they attempt to elude in all sorts of humorous ways. Again, the building features the slide-away paintings, secret entrances and trap doors that figured in the two previous films, and the general premise is pretty much the same even though the dialogue here was cut to the absolute minimum.

Clearly Christensen was repeating himself and was not shy about doing so. He would later state that he considered his first two pictures with the studio, *The Hawk's Nest* and *The Haunted House*, the best two films he made in America. After that it was a case of diminishing returns, although it must be said that *Seven Footprints to Satan* holds up well today. It's extremely entertaining and is much more than just another run-of-the-mill haunted house comedy as some writers have stated, probably without actually having seen it.

While *House of Horror* was not among Christensen's favourites, it did lead to the discovery of a device that would change the face of filmmaking – the sound boom, if his somewhat shifting (and never independently verified) recollections of the event are credible.

As he recalled in an interview in 1952: "At the start [of the sound era] the microphone was firmly secured, forcing the actors to move themselves in relation to it rather than the other way around. I found that to be exceedingly impractical, so during a pause between two takes I sent a man out to find a long bamboo (fishing) pole. We hung the microphone up on the pole and I called over the little comedian, Chester Conklin, and told him, 'now run around the studio, Ches', and just say some stuff and ignore the fact that you're being pursued by the microphone. And it worked, disproving the nonsense that the microphone must remain stationary... a week later the 'discovery' was being used in all the Hollywood studios."[59]

The Invisible Years

After making *House of Horror* Christensen returned to Denmark for the first time since he'd departed for Hollywood in 1925. On 27 March, 1929, his ship docked in Copenhagen, and the next day a reporter from a Danish paper caught up with him to hear about his great adventures:

Benjamin Christensen came home yesterday from Hollywood and went trundling about in the Spring sunshine, an imposing and good-humoured figure among the crowds on Strøget. He is here on vacation. In recent years he has made four films for First National Studio, one of them with Milton Sills and one a 'talkie,' and now he thinks that's enough for a while.

Q: How long are we going to be able to keep you over here?

A month or two. Over the course of time a lot of Danes have ended up over there and have established their own little colony. It's quite cozy and we often get together.

Q: Are you yourself satisfied?

I am happy. Very simply put, I'm happy with my work. And you know that the last half year has been the most interesting in the whole history of film!

Q: Why?

Because of sound film. I myself directed one and I was as delighted as a child at Christmas who gets a really, really entertaining toy to play with. [Christensen did indeed 'play' around with sound. In one of his first sound films he had a woman with a very beautiful voice singing a sentimental song by Stephen Foster while at the same time a dog howled in the most frightful manner.[60] –ed.]

Q: *What does a sound film demand of a director?*

He needs to have experience from both film and live theatre. It is in a way very complicated and demands a great sense of fantasy. It's not enough to throw out a good idea and just go from there.

Q: *How does one shoot a sound film?*

We use lots of microphones. For a radio broadcast you can use just one but when shooting a film you have them hanging all over the set decorations and props. Every single set-up and person requires a microphone. And inside a booth sits a man known as a sound-mixer. That is a completely new job in the film profession. He sits in that booth and listens to all the signals coming out of these microphones, and then the director himself goes into the booth to make sure everything sounds right. These days it is not enough anymore if everything just looks right.

Q: *And if the sound is badly recorded, is the film unusable?*

Well, we're already able to play back the sound three minutes after the scene is shot so we pretty much know immediately if it's successful. And the sound is often recorded miles away from the studio itself. For example, when I recorded my sound film for First National the sound was sent to us through the telephone lines...

Christensen also had some business to attend to in Copenhagen regarding the 1,500-seat Park Theatre which the government had granted him co-ownership of back in 1925.[61] The theatre was newly built and hadn't actually opened until October 1926, approximately a year after Christensen's departure to the States. The problem was that he had been in the US the whole time and had yet to step foot inside the building despite earning tidy sums from it. He hadn't even attended the grand opening, not least because the invitation,

sent by regular post, hadn't reached him in Hollywood until four days after the event had taken place.

This failed to mollify critics who complained about the situation on the floor of the Parliament, and he was now compelled to defend himself in that hallowed hall. While it was pointed out by at least one journalist that his contract had taken all this into account, he was nevertheless forced to relinquish his share of the enterprise. (The building still exists today, located next to the Parken sports stadium in the Østerbro neighbourhood, though it's been remodelled in such a fashion that only the balcony remains intact as a functioning cinema.)

It took him longer than expected to tie up all the loose ends of his life in Denmark and he didn't make the voyage back across the Atlantic until 1930. He had now been gone a full year and it was a very different Hollywood he came back to – a town and a film industry badly rattled by the Great Depression. Lock-outs and strikes were now commonplace. And, as he would later reflect with some bitterness, a whole flock of Broadway directors who knew little about film had come out to Hollywood in the wake of the 'talkie' boom to occupy all the vacant directing jobs.

He had been gone too long, nobody knew him anymore. And in the meantime many of the Scandinavian film people – directors, actors, technicians – that he had fraternized with had returned home. Christensen now also left Hollywood, moving into a cottage on Santa Monica's Venice Beach. It was a house he would describe as being "so close to the water that one can almost roll out of bed and into the sea." But he still had big plans and Hollywood was still the key to his dreams.

His main ambition at this point was to start an independent production company with his old pal, Wid Gunning. One of their first projects was to be a film based on

the Danish novel, *Street of the Sandalmakers*,[62] which he had acquired the rights to. As he enthused to a writer from *B.T.* in 1932, it was to be an ambitious historical epic made for the international market. Set in ancient Rome, it would feature the excitement and pageantry of pagan festivals and star multitudes of slaves and legionnaires. He later claimed that contracts had already been signed with theatres even before they'd shot a single metre of film,[63] all on the assumption that President Roosevelt's soon to be enacted film code would make life easier for independent producers by outlawing the monopolistic policies of the major studios (who forced theatres to book their product on a 'package deal' basis). But to the surprise of many the new code simply gave 'the majors' a green light to continue as before. This spelled doom for a whole generation of independent producers, Christensen among them. He had survived employees dropping dead on him, the vindictiveness of angry fortune-tellers and hurricanes that wrecked his sets, but the greedy bottom-line politics of American big business was the final blow.

Another hindrance for Christensen would have been the Production Code of 1934, which stipulated in detail what was and was not permitted to be shown on screen. It was forced down the throats of the studios by the Catholic Legion of Decency in response to growing popular outrage over the increasing 'decadence' of Hollywood movies and the immoral dope-ravaged lifestyles – as the dim view would have it – of the people who made them. Had that been implemented earlier, he never would have gotten away with some of the scenes he'd included in *Seven Footprints to Satan*, for example. American movie making was about to become decidedly less daring, less sexy and less weird, and it's hard to imagine Christensen being a part of that particular scene.

His years on Venice Beach remain a bit of a mystery. Although he had a house by the sea (so typically Danish), it apparently wasn't enough to fend off bouts of homesickness, as illustrated by one of the few episodes from this period he later deigned to recount to a writer: "I remember one night on New Year's Eve back in the Thirties when I had some young people visiting me in my beach house in Santa Monica. A young American fellow suggested that we ought to all go out into the water when the clock was a little past midnight, and five minutes later we all lay there together in the surf. The water was just as warm as it is here (in Denmark) in September. That's all great but I can assure you that one eventually becomes dead tired of California's climate. You can't stand the sun after you've been there a couple of years.[64] One longs to feel a fine snow in one's face or to take a plunge in real water on a December day. People in California fail to experience the blessings of the changing seasons. They hardly know what a real spring is."[65]

Now in exile from his 'life in exile,' it's natural to wonder what effect these reversals of fortune had on him and what kind of life he was living there on the beach. He was exceedingly circumspect about this period. When asked by a scribe what he was up to at this point, his response seemed purposely vague: "I go for a swim, walk around, rest, enjoy life."[66]

Could it have been that prosaic? Hollywood and its environs attracted would-be starlets from all over the country who dreamed of meeting just such a Hollywood director, and he was after all estranged and half a world away from his wife back in Denmark. Was he perhaps indulging in the kind of decadent, bohemian lifestyle that the aforementioned New Year's Eve episode so tenuously hints at? Midnight flings like this out into the surf were at that point becoming staple

scenes in exploitation cinema. The most famous such scene takes place in the 1936 Dwain Esper-directed drug melodrama, *Marihuana: Weed with Roots in Hell*. Here, after a night of blowing dope with randy male cohorts, a gaggle of loose women decide to go skinny-dipping on a stretch of sand assumedly located not far from Christensen's own shack. Fiction, yes, but...

Some of the short stories in the semi-autobiographical book, *Hollywood Destines*, he published later hint at a foot-loose existence. In *Koloratur*, he describes a fiery young beauty who goes skinny-dipping with him in the sea and whom he sleeps with that night. (From a repressively religious home, she goes on to become a Hollywood star). In *Hollywood Mysteries* he meets an available young pretty after both of them burst out in laughter at an Ape-and-the-Virgin movie and are compelled to leave the theater.

Whether on not the film colony really was as corrupt and decadent as the yellow press claimed can never be known, but it was without a doubt a town full of temptations for those with a name and connections, and Benjamin Christensen had all that. He was, after all, a lover of life as well as the man who had made *The Witch*.

And yet other evidence (equally circumstantial) paints the picture of a fellow who was becoming a hermit. What was really going on with Benjamin Christensen at this point is fated to remain a mystery. Perhaps he was just nursing his personal doubts and frustrations in solitude, but he was in any case clearly becoming a different person, and toward the end of this period on Venice Beach he dropped out of sight. And when he moved back to Denmark in 1935 nobody there was even aware of the fact. The tabloid, *B.T.*, eventually got to the bottom of the case in their 30 June, 1936 issue:

WHATEVER HAPPENED TO BENJAMIN CHRISTENSEN?

That's the question film people ask each other whenever they get together.

Those of the young generation hardly even know his name, but we who have more years behind us have not forgotten The Mysterious X, when rats crawled over the face of the villain, Spiro, or Blind Justice. Back then Danish films were not based on childish manuscripts as they are today. One demanded excitement and also a certain logic from the writer.

Christensen was probably the most important, albeit difficult, of all directors here in Denmark. He could make many mistakes, as for example with The Witch, but he never degraded himself by making a predictable bird-brained comedy. He never compromised.

And once again the question hangs in the air, 'Whatever happened to Benjamin Christensen?'

An anonymous source who should know gave us this reply some time ago.

"He lives by the Pacific coast in Santa Monica, outside Hollywood. There he sits and waits for one film mogul or another to make him an offer. He is too proud to offer his services directly... He must live up to his own expectations. He works through the days, always busy on an idea for a great or a strange film. He receives visitors with reluctance. Passers-by should preferably take the long way around his inauspicious little house on the edge of the beach. He lets pushy friends know without beating around the bush that their presence is not wanted. He spends very little money and lives off what he has saved so as to be able to bide his time until another chance comes along. A Danish housekeeper cooks his meals."[67]

That's what a very knowledgeable source told us, and that was also very much the truth – until about a year ago when Christensen disappeared from Hollywood and environs. No one, not even those few who were in his confidence, knew what had become of him.

But today we can reveal the secret: Benjamin Christensen has for some time been living incognito in Copenhagen. He lives on Henrik Steffensvej # 9, at the corner of Grundtvigsvej, in a beautiful 4th floor flat which he has imaginatively decorated in a Chinese motif. And yet even though his name and address do appear in the directory, no press or film people have thus far seen anything of him as he only infrequently goes out, and attempts as far as possible to remain anonymous... wearing dark glasses and with his collar turned up around his ears! And one does not gain admittance into his abode without banging the doorknocker in a kind of pre-arranged code. Christensen loves mysticism, and even on this quiet, prosaic side-street in Copenhagen's Frederiksberg neighbourhood he manages to live like Dr. Fu Manchu.

He never became good friends with Hollywood and the American film moguls. He was too big a man for them to slaughter. He was not capable of just saying 'Yes! Yes! Yes!'... so now he's back."

It was a very different Benjamin Christensen that had returned, and yet he was anything but a broken man. He had great plans. The article continues:

Most recently he's been working day and night on some big film ideas. He's just dotted the 'I's' and crossed the 'T's' on some manuscripts which are far more ambitious than the Danish norm and which could not possibly be produced here. Thus he intends

to travel to London in the near future to discuss the possibilities with his friend from Hollywood days, Alexander Korda, an important figure in the English film industry and a man who believes and who has gotten others to believe that worthwhile films can be made outside the US. Korda was likewise no great success in Hollywood... he and Christensen have much in common, first and foremost the fact that they have never consciously underestimated the public.

Like so many of Christensen's plans, those with Korda never bore fruit and he was fated to remain in Denmark and make his next film there. He could forget about the great Roman epics for the international market. Danish studios could not manage spectacular productions and on top of it the industry was in a state of severe contraction. And to make a film in spoken Danish – now that all films were 'talkies' – was, it goes almost without saying, no plus on the world market. Although in later years Christensen would concede that there were great advantages to be had in working in one's native language, this was a humbling come-down and he did not accept it without protest, criticizing in a series of editorials official state film and tax policies that he considered counterproductive.

Benjamin Christensen, 1936.

The Danish Comeback and 'The Witch' Revived

In 1936 Christensen secured the rights to the Danish novel *Children of Divorce* and worked it into a screenplay which Nordisk Film Company produced in 1939. This was to be the first of three 'social problem' pictures that he would make for the studio. These were movies based around contemporary issues with an aim to prod the viewer's sense of moral responsibility and stir debate, and they constituted his 'Danish comeback.'

Children of Divorce painted a grim picture of the egotism and moral laxity of single parents and dramatized the negative effects that such behaviour had on their teenage children. It's hard to imagine a film more at odds with the 'perversity' of *The Witch* than this, but, as noted, a rationalist-humanist dimension could be read into almost all of Christensen's earlier work. So while these films marked a stylistic departure for him they also heralded the re-emergence of the 'progressive Benjamin Christensen' who had shown concern for the unjustly imprisoned in *Blind Justice* and the victims of hysterical persecution in *The Witch*.

The film was a critical and public success, with some reviewers hailing it as the best Danish sound film yet.[68] Still a bit of a ham, Christensen appeared in a brief cameo as the salty old skipper, disguised behind a beard and a cigar, and firing off a single line in his limited English; "Get the hell out of here! Hurry up!"

He followed it up with *The Child* in 1940. Here a young couple struggles with the torment of an unplanned pregnancy

Benjamin Christensen and author Leck Fischer.

and the resultant social ostracism. It was a bold examination of another sensitive social topic, abortion, and was also successful. Christensen was gaining (or rather re-gaining) a reputation as a filmmaker of importance who took chances.

Come Home with Me was the final instalment of his 'social issues trilogy.' It dealt with an altruistic female attorney who forms personal bonds with her troubled clients in an effort to help them, while the one most in need of understanding is her ne'er-do-well and all too imperfect husband. This touching and intimate drama was more about the ambiguous divide between

true compassion and 'do-gooding' self-righteousness than about social injustice in any broader sense. It was based on a theatre piece by Leck Fisher. He had penned the screenplay for *The Child* and did the same here. Christensen had very little control over the script but still managed to coax the kind of performances from acting greats Bodil Ipsen and Johannes Meyer that would win him comparisons to Frank Capra and Eugene O'Neill.[69]

With these films for Nordisk, Christensen proved himself to be a disciplined filmmaker who could deliver the goods on schedule and on budget, a man who had reined-in his desire to experiment and who could concentrate on story and acting, albeit at the expense of atmosphere. The lighting in most of these films, for example, is characteristic of standard studio set-ups. In a purely technical sense, these films were more akin to the 'assembly line work' he had always despised. That great, groundbreaking work of personal obsession, *The Witch*, now seemed but a distant memory.

Not so distant, actually. All of a sudden in 1941, just as the newly reinvented, politically-correct Benjamin Christensen was taking bows and receiving absolution for past sins, that film came back from the dead.

After its opening run *The Witch* had been shelved and forgotten and was by this point considered a 'lost' film. Unlike today, when video and digital copying technologies guarantee the preservation of almost every movie on some format, this was a time when the destruction of a single 35mm print could mean the end of a film's existence. With no television exposure possible and with 'theatrical revivals' still extremely rare, a film that flopped rarely got a second chance and was often just liquidated for its silver content or dumped in a shed somewhere and left to crumble. The basic assumption was that

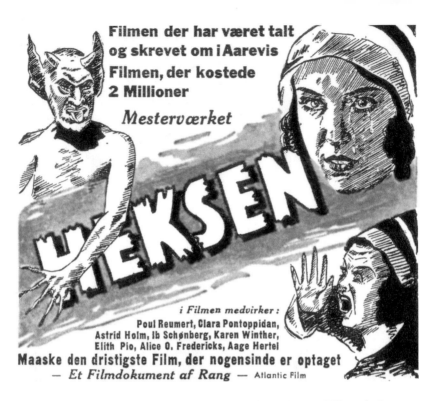

above and opposite: *Admats for the 1941 Danish re-release of* **The Witch**.
"Heksen, the masterpiece which has been talked about and written about for years," reads the text on these ads. "...The film which cost two million kroner... Maybe the most daring film ever shot, a film document of high status."

The Witch had suffered precisely this kind of fate. As a journalist had previously speculated in the 28 December, 1936 edition of *Politiken*, "It has been 15 years since *The Witch* was made, and if a print could even be found at this point the celluloid would shatter like glass. What audiences would think about this film today will never be known."

But the chief of Denmark's Atlantic Film Company had been searching high and low for the film and four years after this pessimistic prediction he discovered a print lying in a

storage facility in Stockholm. It was, judging by the Danish film board censorship stamp, the exact same print that had screened at the premiere at Palads Theatre on 7 November, 1922. By a stroke of incredible luck it had been preserved in glycerine and stored in metal cans and was determined to be in excellent condition.

It was brought back to Denmark for a proper revival and was given an advance screening on 21 November, 1940 for a select group of cultural VIPs. Improvised musical accompaniment was provided at this sneak preview, which Christensen was unable to attend.

On 3 March, 1941, the film began its revival run at the Dagmar Theatre, with all proceeds going to benefit the Danish

actor's guild. A new print had been struck for the occasion, dubbed with a new musical score composed by Emil Reesen.

There had been some talk about re-editing the film and making it shorter, and Christensen himself had his reservations, particularly concerning the concluding 'modern chapter.' As has been shown, this was the most frequently criticized part. It did seem oddly disjointed in style and tone as well as somewhat superfluous, and from a scientific perspective Christensen had failed to bring the same enlightened sense of balance and insight to his own time that he had bought to bear on the Middle Ages. He was also reportedly less than thrilled with his own hammed-up performance as the Devil and was aware that the speeded up movements of the actors in some places marked the

movie as a product of the silent era in a manner that now seemed passé. No matter – "The film must stand or fall on its own," he stated in the press, and it was left untouched.

Christensen gave a talk before the Dagmar screening, received a bouquet of flowers and was heartily applauded. The city's press and public held their collective breath. Would *The Witch* hold up after all these years or prove an embarrassment the way that so many silent-era films did, films that now seemed unintentionally comic and ridiculous and which were hard for the modern viewer to relate to.

One might also wonder how a film about hysterical, brainwashed crowds and the brutal persecution of a scapegoated segment of the population went down at a time when Denmark was occupied by the German army and swastikas flapped from every other flagpole. These were tumultuous days and the echoes of deeper issues reverberated even in the normally isolated, escapist sanctum of the movie theatre. Even films that apparently had nothing to do with the War now assumed a political dimension. An example: *The Harvest Is in Danger* (*Kornet er i fare*), a public service agricultural short from 1944. This 9-minute film indirectly equated the destructive effects beetles were having on the harvest with the havoc Germans were wreaking on Denmark. The narrator uses military terminology and closes by exhorting viewers to join the fight against the destructive, parasitic beetle. "Denmark's harvest is at stake!" he barks – an ever so minor variation of the well known resistance slogan, "Your freedom is at stake!"

It would be hard to believe that the themes incarnate in *The Witch* did not resonate in a similar manner with at least some viewers. The witch hysteria was contingent on travelling tribunals of 'witch hunters' who transformed the countryside into a kind of fascistic police state, exactly as the Nazis had

transformed Europe. In both situations bribery and torture was commonplace while suspects were administered loyalty tests and the use of informers, who often had ulterior motives, was widespread. Speculation of this sort is absent from contemporary discussions of the film in the press – no surprise since the Nazis kept a close watch on the Danish media.

In any case, the re-launch was eagerly anticipated. Everyone seemed to be aware of *The New York Times*'s comment that *The Witch* was 25 years ahead of its time. Was it? A couple of weeks previous a writer credited as Mr. Allevegne, who had already seen the film, attempted to answer some of these questions. The following excerpt is taken from *Social Demokraten*, 21 February, 1941:

THE FILM THAT WAS FAR AHEAD OF ITS TIME

The Witch was the first really big film that Benjamin Christensen directed. It cost a million Danish Kroner and preparations for the filming took several years. The shooting itself took place almost exactly twenty years ago.

Its revival is an event, if only because it is such an old film, and yet it's all the more interesting because upon its release the film was said to be 25 years ahead of its time. If that was true then it should be perfectly suited for showing today!

Was the Film Ahead of Its Time?

The other day I had the opportunity to see The Witch *and must answer that question with both a yes and a no. Many of the pictures are, from a technical standpoint, so excellently made that they could hardly be improved upon today, but other parts, particularly the film's ending, seem a bit antiquated.*

The Witch is not a film in the normal sense. Christensen himself called it a cultural-historic lecture transformed into (moving) images and he intended first and foremost to describe the gruesome persecution of witches and the causes behind it, such as the belief in demons and devils. We page through the old books on superstition and see images of witches that come to life... we see the torture instruments used on witches who cook love potions. This part is so masterfully and convincingly described, and with such effect, that a cold shiver runs down one's spine when these images are shown again.

Are We Better Than We Were in the Middle Ages?

The section of the film that seems a bit antiquated is the last part where Christensen has had the otherwise excellent idea of taking the lecture further into 'the present day.' He raises the question as to whether modern man is superior to his forebears of the Middle Ages who cultivated this belief in witchcraft. Don't we still consult fortune-tellers and soothsayers? Don't we read dream books and do the strangest things if a black cat crosses our path?

Then he leads us into a neurologist's waiting room where a woman suffers from a case of possession... this is the last scene and is not really credible when one knows just a bit of Freud. But when (the renowned) professor Viggo Christiansen has given the film his stamp of approval we must also go along with it.

Will the Film Give Rise to Protests?

When it first came out the film gave occasion to forceful protests. A campaign was launched against it in the press and some demanded that the picture be taken off the screen immediately.

Christensen defended himself by claiming the support of men of science and asserted that those directing the attacks were not keeping abreast of modern developments and currents of thinking. In the twenty years that have passed we've become less prudish, but I believe that the film will again spark discussion. There are scenes in it that are so strong that the average ticket-buyer will hardly be able to digest them, and the torture scenes in particular can have an unfortunate effect on morbid or obsessive individuals. But nothing is censored out of the film although it goes without saying that it will be forbidden for minors.

Ib Schønberg As a Gruesome and Sadistic Monk

There are also things in the film that today take a bit of the edge off the worst scenes. We see sequences from a torture chamber where the monks order the most appalling torments to be administered to a young woman. Then we recognize one of the monks. Isn't that him? Yes it is! That's our own 'Ibber-man' – Ib Schønberg, who sits there behind the judge's desk cruel and gruesome. Then we smile. The whole thing is probably not as bad as it appears or Ib Schønberg would never have participated.

That was Schønberg's first film and on top of it he played a kind of a villain[70] ... We see other now-famous actors as they looked then. Poul Reumert is a slender youngster... there's also Albrecht Schmidt, Carlo Wieth, Clara Pontoppidan, Tora Teje (a Swede) and the dear, round Oscar Stribolt – and he was impossible to turn into a villain. He plays a monk with an appetite for life and a weakness for the charms of the fairer sex, and his appearance provokes a jubilant reaction in the audience.

The Lead Part Is Played By an Old Woman Who Sold Violets

In one respect Christensen was far ahead of his time. The Russians attempt to make films in which they use 'regular people' who are perfect 'types,' rather than (professional) actors, and Christensen was doing that twenty years ago. The leading role is played by a little old mother figure, and her face is unforgettable. She wasn't an actress. Christensen found her on the street selling violets... That this miserable old woman is accused of being a witch arouses sympathy in the audience.

The Film Re-discovered By Pure Accident

The Witch is scheduled to play at the Dagmar Bio next week when Niels Pind and His Boys is taken off and it will be exciting to see how the public reacts to the revival.

But whatever one can say for or against the film, it is indisputably a document of high standing. What's more, the fact that we even get to see it again is the result of an accident. When the film was taken off screens it ended up in the archive of the Swedish studio that produced it and was forgotten. It was found there a few months ago. After having languished for twenty years in an environment that wasn't good for film one might have feared that it was completely ruined, but in fact it was well preserved. Now hopefully they will take better care of it. Perhaps there will be more enjoyment to be gained from it in another twenty years.

This new print sported an introduction by Christensen wherein he discusses the differences between silent and sound cinema, and elaborates upon the four types of 'witches' that existed and are represented in the movie.

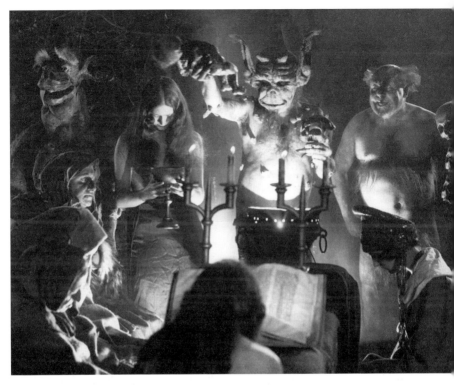

The Devil administers to his heathen flock of witches by sacrificing a baby.

First there were the 'professional' witches, women who practiced folk-magic and occasionally produced some kind of result based either upon the (usually herbal) concoctions they cooked up or upon the fact that people simply believed their remedies worked. Not all witchcraft could be put down to superstition – sometimes results were produced! Second came the disfigured old hags, reviled and unfortunate beggars and outcasts who aroused suspicion and were easy targets. Then there were the 'hysterical' women who through some mental affliction were prone to exhibit suspicious symptoms or make

fantastic and deluded claims and charges. Finally there were average middle-class women who were simply informed upon and had confessions tortured out of them.

Public reaction to the re-launch was overwhelmingly positive, no doubt in part because Christensen was now a 'respected' and 'important' director and because times had indeed changed. Minor criticisms were voiced about his constant use of the first-person form and the frequent appearance of inter-texts, which some felt disrupted the dramatic flow and hindered the actors from delivering fully-realized performances.[71] But the public was in no mood to quibble; over 24,800 people pushed through the turnstiles of the Dagmar Theatre during the first week, setting a new house record. This was no mouldy artefact of silent cinema. Christensen's intricate staging and lighting set-ups and his use of close-ups, shunned at the time as a technique that was too graphic and almost indecent, gave his film dramatic sophistication and visceral impact. After its run there it rolled out to the smaller towns in the provinces.

Mr. Allevegne's aforementioned prediction that the film could have unfortunate effects on "morbid or obsessive individuals" apparently came true in the town of Horsens that fall as a 19 September, 1941 article in the national daily *Ekstrabladet* testified:

VIEWING OF THE WITCH CAUSES CRAMPS

The twenty-year-old Benjamin Christensen film, The Witch, *is currently being shown in Horsens where it is making a strong impression on the public. Last night the police found a 23-year-old man wandering the streets of town short of breath and with his arms stiffly extended out in front of him. At first it appeared he*

was intoxicated but officers quickly determined that was not the case. He was put into an ambulance and taken to Horsen's County hospital where he was given artificial respiration and held overnight before being released. According to information the police received, his condition was caused by the movie, The Witch. *During some of the film's more intense scenes he became hypnotized to such a degree that it caused him to develop cramps.*

The revival of *The Witch* also gave rise to the publication of a book, *Witchcraft and Superstition Through the Times*. The author, William Sieverts, was so influenced by the movie that almost the whole of Christensen's filmed prologue was included in the book's introduction. Sieverts explored a range of related historical phenomena that Christensen had not touched upon, the ghastly crimes of Gilles de Rais among them. Yet his conclusions, as one reviewer noted, could tend to be a bit "far out" – like his contention that jazz music could be equated to witchcraft.[72]

Most interesting was his account of a witchcraft panic that plagued Køge, a small harbour town south of Copenhagen, where between 1608 and 1615 fifteen women were burned on bonfires. It all started when one Hans Bartskjær saw "a terrible toad walking from a gate on two slender legs." Bartskjær had probably been suffering a drunken delirium and had seen a sick dog contorting its body, but everyone in his house was terrified and became convinced that a witch must have let the monster loose. The first to attract suspicion was a woman who had once wished Bartskjær bad luck after a business transaction between them had gone bad. The story of the Køge hysteria was later published in Latin and became a great popular success, and much later it formed the basis of a "vaudeviller" called *The Harridans of Køge* (*Køge Huskors*).

The revival of *The Witch* gave Christensen occasion to weigh in on the sound-vs.-silent cinema debate. Like Charlie Chaplin he remained a staunch advocate of the art of silent cinema long after 'the talkies' had won out. He was asked if he could imagine *The Witch* remade as a sound film:[73] "That would naturally be impossible – how does the Devil talk, for example? Silent films had many drawbacks but also advantages. Sound film is objective; everything is explained through dialogue and they need not engage one's sense of fantasy. Sound film completely lacks the illusion and poetry of silent cinema; one cannot dream and fantasize further about the adventure and the characters contained in the film. Here we've lost a bit of ground and that is one of the most important tasks sound film has before it, to recapture the lost ground. I would like to make another silent movie if I could find the right manuscript for a film completely without dialogue, a film where the images alone engage one's sense of fantasy and set dreams in motion."

*Programme cover for a revival screening of **The Witch** in Brussels in 1948.*

ECRAN DU SEMINAIRE DES ARTS
A. S. B. L.
PALAIS DES BEAUX-ARTS – BRUXELLES

SAISON 1948-1949
DEUXIÈME SÉANCE D'ABONNEMENT

★

BENJAMIN CHRISTENSEN
**LA SORCELLERIE
A TRAVERS LES AGES**
(HAEXAN)
(1921)
précédé de
TROIS FILMS EXPERIMENTAUX DANOIS
et suivi
du DEUXIEME EPISODE de
TIH-MINH
de LOUIS FEUILLADE

LE MARDI 2 NOVEMBRE 1948

Journey Into Twilight

Christensen never found another 'silent movie' script, but his next film, *The Lady with the Light-Coloured Gloves*, was heavily inspired by silent cinema. Like *The Mysterious X*, it was an attempt to make a spy thriller for the international market, but Danish film now played a much more marginal role in the global marketplace.

The social problem pictures had provided scant opportunity for Christensen to indulge his passion for effects and atmosphere and now he made up for lost time, employing inventive camera angles, lighting effects, masks and other post-production processes now available to him. The first reel was packed with visual punch. But even here Christensen was showing his age as the expressionist trappings he now employed in a tribute to the evocativeness of silent cinema – such as the long shadow of a pistol-clutching assassin – were no longer powerful stuff. And the excitement pretty much ended after the first spool, the film bogging down into a hard to follow story about a murky series of double-crosses.

Set during the First World War, *The Lady with the Light-Coloured Gloves* tells the tale of Torben, a Danish engineer who checks into a mysterious hotel carrying a secret letter that later, in a neutral country, he is to pass on to the Czar's personal emissary. But the hotel proves to be a hive of criminals, shady swindlers and spies, and when his best friend, a young Russian courier, is found dead the plot thickens.

It was apparently very loosely based on experiences Christensen had when travelling through Europe to sell *The Mysterious X*. Those had been exciting, adventurous times.

Momentous world events were unfolding around him as he moved from country to country with a print of the film in his trunk, meeting all kinds of colourful characters on the fly and matching wits with border crossing guards and the like. As John Ernst notes,[74] he himself was actually embroiled in a minor intrigue when he was unwittingly duped into acting as a courier for the Czar's secret police (though Ernst deems the incident to have been the stuff of farce rather than high drama). And a similar story, entitled *Film and Reality* (*Film og Virkelighed*) is contained in his book, *Hollywood Destinies*. Here documents are secretly planted in his suitcase.

It was natural that Christensen would draw upon his own experiences, but the film fell flat according to most critics. Stereotypical characters were caught in absurd situations. The actors seemed to be play-acting spies, clumsy ones at that. It was as far behind its time as *The Mysterious X* had been ahead of its, and – with the Nazis occupying Denmark and the outcome of the War still very much in doubt – it was badly out of synch with present-day realities. At its premiere the audience laughed in all the wrong places.[75] It was hopelessly naïve, its low-camp excesses reportedly the only thing to recommend it to ticket-buyers looking for a reason to chuckle in grim times. (Though at least one Danish film scholar claims the movie was not nearly as bad as all that.[76])

It went down as one of the biggest fiascos in Danish film history and must have been a huge blow to both Christensen, who had spent a great amount of time, care and effort on it, and also to his studio. There were at least two more books he wanted to film and he proposed these projects to Nordisk but they turned him down. In 1943 he wrote to a friend that he now considered his relationship with the studio to be terminated.[77]

After *The Lady with the Light-Coloured Gloves*, the Danish film industry was through with him and he eventually accepted this too. In 1945 he told a writer that he had no intention of making another film, adding, "people here think that the only kind of film I can make is one that has trolls and witches in it."[78] Better that they remember the trolls and witches than the bumbling spies.

Christensen continued to make his opinions heard in the press, and in 1945 published the previously referred to book of short stories, *Hollywood Destinies* (*Hollywood Skæbner*). Spun from a mix of autobiography and fiction, these stories are not all movie related but frequently elaborate upon themes that he dealt with in his films and with experiences he had while travelling around on film business.

The previous year he had been granted a license to operate another cinema, the 500-seat Rio Bio in the lower-middle class suburb of Rødovre – nothing so fancy as the Park Theatre this time, but he was grateful enough. He was getting on in years and this supplied him with a living income and contact with the movie-going public which gave him much pleasure. Not 'his' public, since he never exhibited his own films (out of principle), and not a sophisticated 'big city' public, but just regular folks. He seemed to enjoy the job, particularly when the theatre was full of youngsters who affectionately called the gangly, gaunt old fellow with the round glasses "the movie man."

Otherwise he guarded his privacy jealously. He rarely ventured out in public, preferring to stay home with Kamma in their cozy Fredericksberg flat on Lindevangen, which was crammed with the books and oriental antiques he had collected over the years. Other great figures of Danish silent cinema also called this quiet neighbourhood of stately stone

apartment buildings and leafy boulevards home; Carl Dreyer lived over on Dalgas Boulevard and Asta Nielsen around the corner on Peter Bangs Vej.

The years wore on.

Every once in a while film people would again start asking, 'whatever happened to Benjamin Christensen?' And inevitably journalists would find their way into the cluttered sanctum of his home to be regaled with stories of the old days. On one such occasion a photographer got him to proudly pose beside a treasured collectable; a thousand-year-old engraved Chinese tombstone. He would laugh off the inevitable inquiries as to how a world famous movie director who had 'conquered' Hollywood could find contentment running a neighbourhood cinema in humble Rødovre. He seemed a man at peace with himself and reconciled to the circumstances that fate had dealt him.

On 2 April, 1959, at the age of 79, he passed away after a lengthy illness.

'The Master' whose visage had adorned countless movie posters and glared out from screens all over the world had gone on to make an art form out of anonymity, and he was – as he requested – buried in an unmarked grave in Søndermark cemetery in Copenhagen after a small ceremony that was conducted virtually in secret.

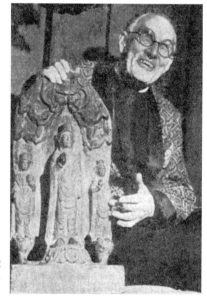

Christensen shows off an ancient Chinese gravestone.

Witchcraft Through the Ages

'The Witch' Lives!

The Witch, Benjamin Christensen's most enduring and significant achievement, would be subject to periodic revivals after his passing.

The Danish Film Museum, for example, staged an ambitious retrospective in 1967, screening all the films which (at the time) could be located, and this gave occasion for John Ernst's penetrating study which was, prior to this book, the only work that had been published (thus far in Danish only) on him.

The following year the film was condensed down to 76 minutes and 're-mixed' by the English filmmaker and programmer, Antony Balch. Balch was a connoisseur of edgy and transgressive cinema and brought many important and previously banned films to British screens, including *Freaks*. He consorted with the likes of Brion Gysin and other high priests of Beat, such as William Burroughs who was living in London at the time. He was involved in several film projects with Burroughs and got him to do the narration for this new version, entitled *Witchcraft Through the Ages*. He also added music composed and performed by percussionist Daniel Humair and violinist Jean-Luc Ponty and other musicians.

In November 1968 this version played at London's Baker Street cinema (slapped with British Board of Film Censors 'X' certificate), sparking a revival of sorts for the film in the UK and earning it countless new fans, despite the fact that at least one critic found the narration to be "rather dully spoken and at times a little arch."[79] Said unidentified critic also seems to have misinterpreted the film in this version as he goes on to

reflect that, "... the conclusion (of the film), that in the enlightened Twenties 'witches' were being kindly confined to lunatic asylums or given therapeutic showers to cure their 'hysteria,' appears only slightly less barbaric than burning them at the stake."

Christensen's message, that things have not really changed all that much and that modern man, in supposed possession of great amounts of wisdom and enlightenment, is still prey to superstition, was of course quite the opposite.

With that said, Christensen was of course basing his assumptions on works available to him at the time and he cites facts and figures then considered accurate. Some of this is today contested by scholars. As previously noted, the commonly quoted toll of eight million deaths is today considered way off, and the role that witch hunters played in spreading the terror has also been called into question, with some maintaining that 'regular people' were far more responsible for provoking the persecutions. Doubt has also been cast upon the ordeal of trial-by-water, which in popular accounts would always seem to lead to the death of the accused woman. (If she floated she was a witch, if she sank and drowned she was innocent.) According to some historians the women who sank were often pulled up in time.

He also fails to directly address claims that persecuted 'witches' were frequently first and foremost victims of economic and/or sexual exploitation. This view is widely accepted today, and in the realm of popular cinema is best represented in the British film from 1968, Michael Reeves's *Witchfinder General*. While Christensen doesn't directly contend that witch hunters and priests exploited women sexually, he really doesn't need to. The scenes in his film of voyeuristic priests spying on accused women as they are brutally interrogated – and often bound, caged

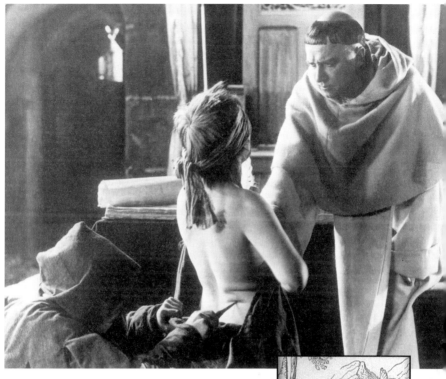

above: *Interrogators prick a woman's flesh to probe for insensitive spots that will prove she is in league with the devil.*
right: *Woodcut of naked woman hog-tied.*

and/or unclothed – say enough about the sadistic sexual dynamics involved. At one point a woman naked from the waist up and seen from behind has instruments of torture applied to her bare flesh. There is also the woodcut, shown more than once, of a naked woman hog-tied on her back and enduring trial-by-water. Female bodies had to be searched for suspicious marks and insensitive spots, and first those bodies had to be unclothed.

The Witch had caught the spirit of the times and in 1968 the film was also revived in Paris, Stockholm and Copenhagen, where Peter Refn scheduled a run at his Camera Bio. A new print was struck, fittingly at the Johan Ankerstjerne film lab, without the dubbed music this time as had been the case in 1941. That was now considered to have been a mistake.[80] This print would be as true to Christensen's version as possible, accompanied by the original music score, which was played at the opening show on 31 May by pianist Kay Kilian. Refn's revival of the film reaped it lots of praise but not all reviewers were positive: "...not a good film, succeeds today only as camp;"[81] "Seen from a modern perspective the film resembles an entertaining museum exhibit."[82]

In February 1970 the Elgin, New York's legendary repertory theater, double-billed the Balch version of *The Witch* with *Wild Horses* by Sergei Parajanov and drew the wrath of underground film spokesman, Jonas Mekas, who in his 'Movie Journal' column in the 12 February edition of *The Village Voice* wrote:

Do not miss the Elgin Theater double-bill opening this week of Häxan *and* Wild Horses... Häxan *was made by Benjamin Christensen in 1922 in Denmark. The film uses old engravings and period re-enactments to present the history of witchcraft. I saw the film years ago at (Amos Vogel's) Cinema 16. I still can't forget the strength of some of the images, the imagination that went into them. I urge you to see the film despite one unfortunate fact: the version which you'll see is the bastardized "English version" prepared by a well meaning but obviously stupid young man, Antony Balch. It takes stupidity to do what he did with this great film. To a beautiful silent film he added a jazz score and a squeaking narration by William Burroughs. The texts, which in the original film appear as titles, as part of the film's structure,*

now most of the time are read by Burroughs. The film has been destroyed. Nevertheless, there is enough left of the original power of the images – particularly if you can keep your ears plugged somehow. Why did Burroughs participate in this barbarous act? Suppose we begin to mess with his novels, I wonder how he'd feel about it..."

Others apparently agree with Mekas. For example when the George Eastman House in Rochester, NY played this version in 2004, they turned down the sound and had live piano accompaniment instead.

In fact the Balch/Burroughs version, which was distributed in the U.S. by Janus Films (who apparently distributed both versions), is not all that bad. The music, an atmospheric mix of jazz and avant-garde, is usually quite effective if at times a bit overwhelming. Burroughs's narration injects in spots a note of irony and dry humour after his fashion. That is something the original version lacks, though the appropriateness of that can certainly be argued.

Condensed to 75 minutes from its original 104-minute running time, the Balch/Burroughs version unfortunately gives short shift to some key scenes, including the witches' flight to Bloksbjerg and the nuns' hysteria in the church. Some torture scenes are shortened, it is less unrelenting, less 'brutal,' but Burroughs's spoken dialogue gives it a more unified (if still disjointed) narrative flow, or at least the feeling of such. It is less clinical, less pedagogic, and the chapterized structure is completely gone, although that never really helped to give Christensen's original version much continuity. His film was in essence an episodic jumble of dreams, hallucinations, dramatic skits and almost scientific presentations of devices or concepts that lacked a focused narrative thread or perspective,

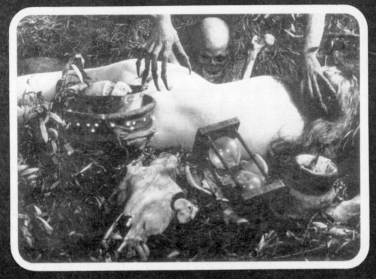

WILLIAM BURROUGHS narrates

BENJAMIN CHRISTENSEN'S

WITCHCRAFT
THROUGH THE AGES

X

AN ANTONY BALCH PRESENTATION

Pressbook cover for the 1968 British re-release of **The Witch**.

and the viewer cannot always be sure of what point-of-view applies. The Balch/Burroughs version is more political, more anti-authoritarian, more 'beat,' as one might expect. In one scene where Maria the weaver[83] is interrogated by two witch hunters, Burroughs laconically observes: "here we see an example of 'good cop/bad cop,' which is still being practiced in police stations all over the world."

After viewing this version, Mekas's criticism seems perhaps a bit too harsh. Can't a film be re-contextualized and re-interpreted? Must all art be fossilized in its original state? Is any alteration vandalism? The question is particularly relevant to this film since it *has* been re-interpreted so many times. It should also be noted that Christensen had to structure his (silent) version around title-plates. This was a necessity, not an artistic choice. And finally, hadn't at least one critic back on the occasion of the 1941 revival criticized the over-abundance of inter-titles for hampering the performances?

Through the years the film has screened in many different contexts: rock stars have appropriated scenes for their videos while avant-garde musicians and even performance artists have used the film as a backdrop for their own creative expressions. In 1995, for example, a touring "Loud Music Silent Film Festival" screened it as part of a performance by Judith Ren-Lay. As the program text reads: "Judith Ren-Lay is one of the foremost performance artists on the scene today. Her background is in dance, but it is her voice and incredibly powerful performances that make her 'live painting' style so memorable. She will be joined by sculptor and multi-instru-mentalist, Ken Butler, for these shows. The film she will be working with, *Witchcraft Through the Ages*, is an early surrealist film from the Swedish [sic] filmmaker, Benjamin Christensen (1922). This controversial look into the superstitious Medieval

mind was banned for years due to nudity and religious irreverence. The bizarre cast of characters seems to have marched right out of a Hieronymous Bosch painting."

In 1996 in its capacity as European Cultural Capital of the year, Copenhagen was flush with money to spend on the arts and among the scheduled attractions was a screening of *The Witch* set to a musical score composed specifically for the event by the renowned French avant-garde art rock quintet, Art Zoyd, who also played their pre-existing scores to *Nosferatu* (1922) and *Faust* (1926).

In 1999 a conglomerate of Danish and American cultural institutions organized a series of Danish art exhibitions and performances in America under the banner of "The Danish Wave." The cinema segment was entitled "Heart of Light: The Danish Wave in Cinema," and focused largely on the Dogme95 movement but also included a 12-film retrospective dedicated to Benjamin Christensen. Both the 'Burroughs version' and the original (fully restored and tinted) versions were screened.

 Many other screenings of the film have occurred in various circumstances and contexts all over the world and down through the years, far too many to mention here. It is a film destined to be continually revived and rediscovered. Rather than just being 25 years ahead of its time it seems to be eternal.

In Benjamin Christensen's hometown of Viborg there exists no memorial to mark his memory, and where his father's drapery shop once stood on the main town square today stands a Blockbuster Video outlet.

But Christensen did finally get a memorial of sorts; when the folks behind *The Blair Witch Project* were working on their film and watching every 'witch movie' they could get their hands on, they stumbled across *The Witch* and were so amazed that they named their production company after it – Haxan Films.

Footnotes

1. *Social Demokraten*, 25 September, 1949
2. John Ernst, Benjamin Christensen (1967, The Danish Film Institute, Copenhagen) p.7
3. *Berlingske Aftenavis*, 30 June, 1936
4. Ibid
5. *Politiken*, 28 December, 1936
6. *National Tidende*, 26 September, 1954
7. Ibid
8. *Berlingske Tidende*, 7 October, 1999
9. 1911-1918 is roughly considered to be Denmark's golden age of silent cinema when their films attained a mastery and exportability that exceeded those of the Americans and was surpassed only by the French.
10. *København*, 24 March, 1914
11. *Moving Picture World*, March, 1914
12. *Politiken*, 28 December, 1936
13. *National Tidende*, 26 September, 1954
14. *Social Demokraten*, 25 September, 1949
15. *National Tidende*, 26 September, 1954
16. The film's Swedish title, *Häxan*, and the Danish title, *Heksen*, both literally translate into *The Witch*. In English the film has been known as *Witch*, *The Witch* and most commonly as *Witchcraft Through the Ages* (although technically that is the title of the version re-edited in 1967). For our purposes we refer to it as *The Witch*.
17. *Berlingske Aftenavis*, 30 June, 1936
18. 'Strong John' in the US version.
19. John Ernst, *Benjamin Christensen* (1967, The Danish Film Institute, Copenhagen) p.10
20. *Berlingske Aftenavis*, 30 June, 1936
21. *Århus Stiftstidende*, 19 April, 1959
22. Benjamin Christensen, *Hollywood Skæbner* (*Hollywood Destinies*) (Copenhagen, 1945, Schønbergske Publishers). Note: His prison encounters were described in the stories *I Sing Sing* (*In Sing Sing*) and *Helt Tilbunds* (*Getting Completely to the Bottom of the Case*).
23. *National Tidende*, 26 September, 1954
24. Ibid
25. Still today in Denmark this longest summer night is celebrated all over the country with the burning of bonfires. In every bonfire a stuffed 'witch' is placed on a pole and as she catches fire she takes to the air and 'flies' to Bloksbjerg. This is known as 'Sankt Hans aften' (Saint Hans night) and is the scene of much festivity and drinking.

26. Somewhere between 40 and 75 women were used as witches - reports vary.

27. Undated article penned by Mogens Brandt from 1941.

28. Account given by Johan Ankerstjerne in *Randers Dagblad*, 1 March, 1941.

29. Unidentified daily, 17 February, 1941

30. *Århus Stiftstidende*, 19 April, 1959

31. These reminiscences published in the 1 March, 1941 issue of *B.T.*, translated by the author.

32. John Ernst, *Benjamin Christensen* (1967, The Danish Film Institute, Copenhagen) p.15

33. Ibid, p.17

34. *København*, 8 November, 1922

35. *Social Demokraten*, 25 September, 1949

36. *Politiken*, 28 December, 1936

37. John Ernst, *Benjamin Christen*, p.20

38. Ibid, p.21

39. Unidentified Danish daily, 28 December, 1923

40. *Politiken*, December 1923, *The Herman Bang film, Michael* by Julia Koppel.

41. Casper Tyberg, *Images of the Master – Benjamin Christensen's career in Denmark and Germany* (published in 1999 as part of the commemorative book *Benjamin Christensen – An International Dane*, issued in conjunction with a retrospective of Danish cinema in America).

42. Excerpted from Christensen's letter to Ove Brusendorf dated 25 March, 1939.

43. Ibid

44. *Ekstrabladet*, 24 September, 1954

45. John Ernst, *Benjamin Christensen* (1967, The Danish Film Institute, Copenhagen) p.24-25

46. Ibid

47. "I couldn't speak a word of English before I went to America," Christensen is quoted as saying in an article by Haagen Hetsch published in September 1949.

48. *Motion Picture News*, "Rapf Sees Era of Improvement," 28 November, 1925.

49. John Ernst, *Benjamin Christensen* (1967, The Danish Film Institute, Copenhagen) p.26

50. *Hollywood Citizen*, 2 September, 1926

51. Arne Lunde, *Benjamin Christensen in Hollywood*, p.27, issued as part of the publication *Benjamin Christensen, An International Dane* (Published in 1999 by "The Danish Wave 99" on the occasion of the exhibition of same name held at The Museum of Modern Art, New York, 9-26 September, 1999.

52. Quote culled from the 8-page MGM publicity flyer for *Mockery* on file in the Danish Film Institute, Copenhagen.

53. John Ernst, *Benjamin Christensen*, (1967, The Danish Film Institute) p.26

54. Arne Lund, *Benjamin Christensen in Hollywood*, p.29

55. *Variety*, 17 April, 1929

56. Programme notes for *Seven Footprints to Satan* issued by The Danish Film Museum in May 1967.

57. It was almost compulsory at this time to release both a sound and silent version of a film.

58. *Hollywood*, 15 December, 1928

59. *Berlingske Aftenavis*, 6 May, 1952

60. *Social Demokraten*, April 1959

61. This was a special favour granted to certain directors by the government as a kind of 'thank you.' Carl Dreyer was granted, in the same fashion, operation of the Dagmar theatre in the '50s and his finances improved considerably as a result.

62. *Sandalmagernes gade* by Nils Petersen.

63. *Politiken*, 28 December, 1936

64. Having shot *The Witch*, *Seven Footprints to Satan* ("...after a night's work on the set." Arne Lund, p.30) and perhaps other films at night, Christensen was apparently no great sun worshipper.

65. Unidentified Danish daily, 22 October, 1945

66. *Berlingske Aftenavis*, 18 December, 1934

67. Her name was Kamma Winther and he married her before returning to Denmark.

68. *Berlingske Tidende/Politiken*, 12 August, 1939

69. Arne Lund, *Benjamin Christensen in Hollywood*, p.37 "...arguably both the wittiest and most moving of the three, resembling at moments a Danish fusion of Frank Capra (*You Can't Take It with You*) and Eugene O'Neill."

70. After his debut as a sadistic torturer in *The Witch* he quickly became typecast as a nice, fat, jolly chap and went on to become one of Denmark's most beloved actors – the "funny, harmless man with a good heart" as Morton Piil characterizes him in his 2001 book about Danish actors, *Danske Filmskuespillere*.

71. *Dansk Familie Blad*, 28 March, 1941

72. *Social Demokraten*, 24 November, 1941

73. Unidentified Danish daily, 25 February, 1941

74. John Ernst, *Benjamin Christensen*, p.40

75. *Jyllands Posten*, 4 April, 1959

76. Maren Pust

77. Morten Piil, *Danish Film From A to Z*, (Gyldendal publishers, Copenhagen, 1998, 2000) p.81

78. Unidentified Danish daily, 22 October, 1945; *America is not just Cars and Bank Accounts* by Jonal.

79. *The Observer*, 3 November, 1968

80. *B.T.*, 31 May, 1968

81. *Jyllands Posten*, 4 June, 1968

82. *Information*, 1 June, 1968, Pim

83. The character that Maren Pedersen plays in the film has been variously referred to as 'Maria the Weaver,' 'Marie the Seamstress' and as simply 'The Witch,' depending on which print of the film is viewed.

Benjamin Christensen Filmography

Each film is listed under its English title, followed by the Danish (and/or German) title in brackets. In the event that there exists no official English title, or one cannot be found, an asterisk next to the title indicates it is a literal translation from Danish. Films that Christensen began but were never completed are also included.

THE BELT OF FATE*
(*Skæbnebæltet* – Denmark), 1912, Denmark
Christensen acted as a blind musician. Produced by the Dansk Biograf-kompagni.

LITTLE CLAUS AND BIG CLAUS*
(*Lille Klaus og store Klaus* – Denmark), 1913, Denmark
Christensen performs as 'Big Klaus.' Produced in Denmark by the Dania Biofilm Kompagni. References can also be found to other films from 1913 also made by the Dania Biofilm Kompagni. One is entitled **THE CORRODI SISTERS** (*Søstrene Corrodi*) and centres on two sisters who attempt to woo the same man. When one wins his love the other commits suicide. Christensen is listed as an actor (only). The other is entitled **CHILDREN OF THE STAGE*** (*Scenens børn*), and was directed by Bjørn Bjørnson with Christensen listed as an actor. Yet another film, **WINGED*** (Vingeskudt), in which Christensen plays a character named Rentier Palm, is credited to Dania Biofilm Kompagni, and was undoubt-edly made about the same time but no year of production is obtainable.

THE MYSTERIOUS X
a.k.a. *Orders Under Seal* (*Det hemmelighedsfulde X* – Denmark), 1913, Denmark
Christensen wrote, produced, directed and acted as the Navy Lieutenant van Hauen. Produced by Dansk Biograf-kompagni. (This film is not to be confused with the 1914 American film entitled *Sealed Orders*.)

THE MAN WITHOUT A FACE*
(*Manden uden ansigt* – Denmark), 1915, Denmark
Christensen wrote, directed and was to produce this film, which was never finished.

BLIND JUSTICE
a.k.a. *Night of Revenge* (*Hævnens nat* – Denmark), 1915, Denmark
Christensen wrote, directed and played the role of Strong Henry ('Strong John Sikes' in the US). Produced by Dansk Biografkompagni.

THE WITCH
a.k.a. *Witchcraft Through the Ages* (*Häxan* – Sweden / *Heksen* – Denmark / *La sorcellerie à travers les âges* – France), 1922, Shot in Denmark but

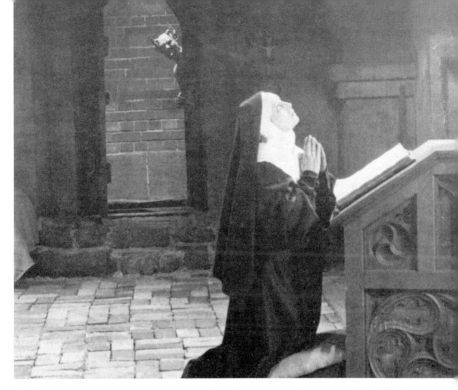

Benjamin Christensen, playing the Devil, spies on a praying nun in **The Witch**.

produced by a Swedish company. Written and directed by Christensen, who also starred as the main Devil. Produced by Svenska Biografteatern. (There is also some indication that in 1922 Christensen began work on his planned follow-up to *The Witch*, *The Woman Saint* (*Helgeninde*), which however was quickly abandoned.

HIS MYSTERIOUS ADVENTURE

(*Seine Frau, Die Unbekannte* / *Wilbur Crawfords wundersames Abenteuer* – Germany / *Hvem er hans kone?* – Denmark), 1923, Germany
Directed by Christensen.

Produced by UFA. Sketchy references can also be found to another German film from 1923 entitled *Unter Juden* (*Among Jews**).

MICHAEL

a.k.a. *Chained* / *Chained: The Story of the Third Sex* / *Heart's Desire* (Mikaël – Germany), 1924, Germany
Christensen acted (only) in this film, playing 'the master, Claude Zoret.' It was adapted for the screen by Carl Theodor Dreyer and Thea von Harbou after a novel by the Danish author, Herman Bang. Produced by UFA and filmed in Berlin.

THE WOMAN WHO DID
a.k.a. *The Woman of Ill-Repute* (*Die Frau mit dem schlecten Ruf* – Germany), 1925, Germany
Christensen directed this English-spoken film which was based on a novel by British author, Grant Allen and produced by UFA.

THE DEVIL'S CIRCUS
a.k.a. *The Light Eternal* (working title) (*Cirkusdjævelen* – Denmark), 1926, USA
Christensen directed and provided the idea, which was heavily worked over by multiple MGM scriptwriters in the employ of the studio.

MOCKERY
a.k.a. *Revolution / Terror* (working title), 1927, USA
Written and directed by Christensen. Produced by MGM.

THE MYSTERIOUS ISLAND
1926-1929, USA
Christensen was one of three directors who worked on this film, which was completed by Lucien Hubbard and released in 1929. Produced by MGM.

THE HAWK'S NEST
(*Ørnens rede* – Denmark), 1928, USA
Directed by Christensen, produced by First National Pictures (Warner Brothers). Based on a story by Wid Gunning.

THE HAUNTED HOUSE
(*Spøgelser* – Denmark), 1928, USA
Directed and co-written by Christensen for First National Pictures (Warner Brothers). Based on a play by Owen Davis.

SEVEN FOOTPRINTS TO SATAN
(*Syv fodtrin til helvede* – Denmark), 1929, USA
Directed and adapted for the screen by Christensen for First National Pictures (Warner Brothers). Based on a novel by Abraham Merritt.

HOUSE OF HORROR
(*Rædslernes hus* – Denmark), 1929, USA
Written and directed by Christensen for First National Pictures (Warner Brothers).

CHILDREN OF DIVORCE
(*Skilsmissens børn* – Denmark), 1939, Denmark
Directed by Christensen for Nordisk Film. Based on a novel by Alba Schwartz.

THE CHILD
(*Barnet* – Denmark), 1940, Denmark
Directed and co-written by Christensen for Nordisk Film. Based on a play by Leck Fischer.

COME HOME WITH ME
(*Gå med mig hjem* – Denmark), 1941, Denmark
Directed by Christensen for Nordisk Film

THE LADY WITH THE LIGHT (COLOURED) GLOVES
(*Damen med de lyse handsker* – Denmark), 1942, Denmark
Written and directed by Christensen for Nordisk Film.

'The Witch' Cast and Crew Credits

Due to the fact that *The Witch* has been re-issued in a variety of forms over the years, the crew credits include some entries that are specific to only one specific version of the film. Such entries are indicated by the use of *italics*.

CAST

Benjamin Christensen (The Devil/The Fashionable Doctor), **Ella La Cour** (Karna, the Witch), **Emmy Schønfeld** (Karna's Collaborator), **Kate Fabian** (Lovesick Maiden), **Oscar Stribolt** (The Gluttonous Monk), **Wilhelmine Henriksen** (Apelone, a Poor Woman), **Elisabeth Christensen** (Anna, Bookprinter's Wife's Mother), **Astrid Holm** (Anna, Bookprinter's Wife), **Karen Winther** (Anna's Younger Sister), **Maren Pedersen** (Maria, the Seamstress / Maria, the Witch), **Johannes Andersen** (Pater Henrik, Chief Inquisitor), **Elith Pio** (Johannes, the Young Inquisitor), **Aage Hertel** (Inquisitor), **Ib Schønberg** (Inquisitor), **Holst Jørgensen** (Peter Titta), **Herr Westermann** (Rasmus Bödel), **Clara Pontoppidan** (Sister Cecilia, the Nun), **Elsa Vermehren** (Self-torturing Nun), **Alice O'Fredericks** (Nun), **Gerda Madsen** (Nun), **Karina Bell** (Nun), **Tora Teje** (The Hysteric in Modern Sequence), **Poul Reumert** (Jeweller), **H.C. Nielsen** (Jeweller's Assistant), **Albrecht Schmidt** (Psychiatrist), **Knud Rassow** (Anatomist), **Ellen Rassow** (Servant Girl), **Frederik Christensen** (Commoner), **Henry Seemann** (Commoner), **Karen Caspersen** (Woman), **Gudrun Barfoed** (Woman), **Holger Pedersen** (Man), **Carlo Wieth** (Man)

CREW

Written and Directed by: **Benjamin Christensen**. Director of Photography: **Johan Ankerstjerne**. Art Director: **Richard Louw**. Assistant Art Directors: **Helge Norél**, **L. Mathiesen**. Editor: **Edla Hansen**. Script Girl: **Alice O'Fredericks**. Assistant Photography: **Rudolf Frederiksen**. Music: **Launy Grøndahl** *(prelude, 1922 version)*, **Jacob Gade** *(main score, 1922 version. Note: Some sources credit Christensen as Gade's collaborator on the 1922 score.)*, **Emil Reesen** *(1941 version)*, **Daniel Humair** *(1960s version)*. Musicians *(1960s version)*: **Jean-Luc Ponty** (Violin), **Bernard Lubat** (Piano organ), **Michel Portal** (Flute), **Guy Pedersen** (Double bass), **Daniel Humair** (Percussion). Recorded at the Studios Europasonor (Paris). Editions Telecinedis. Narrator: **William Burroughs** *(English 1960s version)*, **Philippe Noiret** *(French 1960s version)*. *Assistants to the sound version:* **Norman Glass**, **Paul Brewer**. *Recorded at Newsreel and dubbing services. English sound version produced by:* **Antony Balch**.

Index

Admat for the 1968 British re-release of *The Witch*.

THE SENSATIONAL SWEDISH MOVIE ... KEPT SECRET FOR 50 YEARS !

BENJAMIN CHRISTENSEN'S

WITCHCRAFT
THROUGH THE AGES
'X'

NARRATED BY WILLIAM BURROUGHS
AUTHOR OF 'NAKED LUNCH'

SCARIFYINGLY BRILLIANT EVOCATION OF WITCHCRAFT...
The GUARDIAN

C I N E M A C L A S S I C S C O L L E C T I O N

You have been reading Volume 1 of the new *Cinema Classics Collection* from FAB Press, a series of budget-priced, highly collectable studies of historically important movies, genres and directors. Look out for Volume 2 in the series: *No Borders, No Limits: Nikkatsu Action Cinema*. Further information about this, and many more titles in the acclaimed range of FAB Press cinema books, can always be found at our website, www.fabpress.com:

www.fabpress.com

For news of our latest book releases, to listen to our weekly film review podcasts, or if you wish to order any of our stock and prefer to pay by credit card or debit card, please visit our constantly updated website. At fabpress.com you can order books in confidence using our **Secure Server Payment System**. We also accept payment by **PayPal**. As well as offering all FAB Press titles at special discounted rates, our online store offers a hand-picked selection of the World's finest **Cinema Books**, **Movie T-shirts** and **DVDs**.

Use any of these cards to shop
online at **www.fabpress.com**